CHRISTMAS TRADITIONS IN BOSTON

ANTHONY MITCHELL SAMMARCO

AMERICA
THROUGH TIME®
ADDING COLOR TO AMERICAN HISTORY

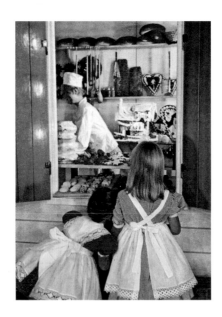

For Bonifazio and Angela Cocuzzo Cedrone and Luigi and Rose Giannelli Sammarco

And the memories of the Feast of the Seven Fishes

La Festa dei Sette Pesci

America Through Time is an imprint of Fonthill Media LLC
www.through-time.com
office@through-time.com

Published by Arcadia Publishing by arrangement with Fonthill Media LLC
For all general information, please contact Arcadia Publishing:
Telephone: 843-853-2070
Fax: 843-853-0044
E-mail: sales@arcadiapublishing.com
For customer service and orders:
Toll-Free 1-888-313-2665

www.arcadiapublishing.com

First published 2017

ISBN 978-1-63500-057-3

Typeset in Mrs Eaves XL Serif Narrow
Printed and bound in England by CPI Group (UK) Ltd, Croydon, CR0 4YY

CONTENTS

Acknowledgments 4

Introduction 5

One Christmas was Banned in Boston! 9

Two Boston Christmases in the Victorian Era 17

Three A Very Boston Christmas 29

Four Boston Common at Christmas 39

Five Christmas Cards, Carols and Season's Greetings 47

Six Boston's Department Stores 65

Seven The Enchanted Village of Saint Nicholas 81

Eight Boston's Christmas Trees 85

Nine The Boston Pops, Black Nativity, Ice Capades 93

Opposite page: Two young girls peer into the Bake Shop with a Han Christian Hofmann-built automated baker that was part of the Jordan Marsh Enchanted Village of Saint Nicholas, which was photographed by *Look* magazine in December 1959. Trays of Bavarian inspired cookies, a gingerbread house and other German Christmas treats such as *nusshaufchen*, *spekulatius*, *pfeffernusse* and *spitzkuchen* were displayed in the bakery window, and also sold during the holiday season in the Jordan Marsh Bakery.

Acknowledgments

Christmas Traditions in Boston is a book that touches upon the aspect of a holiday which was banned in the seventeenth century to what today has become a beloved tradition in Boston. Many people have assisted me in the research and writing of this book, and I wish to extend my sincere thanks to the following:

Susan Agaman; Jeanne Scaduto Belmonte; The Boston Public Library, David Leonard and Henry Scannell; Dolley Carlson; Hutchinson and Pasqualina Cedmarco; the late Bonifazio and Angela Cocuzzo Cedrone; Cesidio "Joe" Cedrone; Edie Clifford; Colortek of Boston, Jackie Anderson; eBay; Mary Anne English; Vincent and Rosemary Donovan Finn; John Goode; Edward Gordon; Katherine Greenough; Margaret Greenough; Helen Hannon; Hofmann-Figuen, Reinhard Hofmann, Martin Hofmann and Doreen Wieland; Bradley Jay, WBZ Radio 1030; George Kalchev, Fonthill Media; the late Bridget Madden; Kathryn Donovan Malt; Martin Manning; Vladimir, Angela and Sebastien Minuty; the late Martin and Mary Madden Mitchell; Frank Norton; Orleans Camera; Mary Devaney Paul; William H. Pear, II; Donna Prefontaine; Lilian M.C. Randall; Joann Riley, University of Massachusetts, Archives and Special Collections, Joseph P. Healy Library, Boston; the late Luigi and Rose Giannelli Sammarco; Ron Scully; John Sullivan; Alan Sutton, my editor at Fonthill Media; Kenneth Turino and Chris Matthias; West End Branch, BPL, Helen Bender; Daniel White; Cathryn Wright; Karen MacInnis.

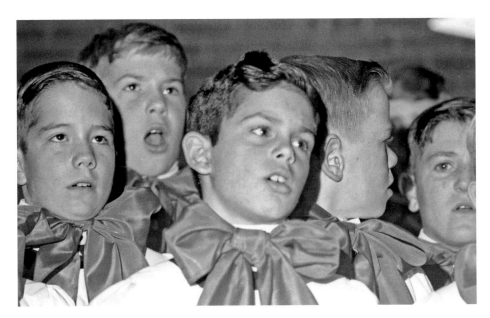

The angelic voices of the young boys of the St. Paul's Choir School in Cambridge, Massachusetts, were a prominent part of the holiday festivities at both St. Paul's Church in Harvard Square as well as choir performances throughout the city. Theodore Norbert Marier served as the organist and from 1947 as choir director at St. Paul's and in 1963, with Monsignor Augustine F. Hickey, he founded the famous choir school and directed it until his retirement in 1986. The school later became known as the Boston Archdiocesan Choir School, and the choir, the Boston Boys Choir.

INTRODUCTION

Christmas Traditions in Boston is a compilation of photographs, woodcuts and illustrations that show how Bostonians celebrated Christmas over the last two centuries, though it had actually been banned by the Puritans who settled Massachusetts Bay Colony in 1630. The Puritans were a stern lot and though officially members of the Church of England, when they sailed to the New World seeking religious freedom, their "City Upon a Hill" evolved into narrow-mindedness.

The Puritans had several reasons to officially ban the celebration of Christmas in Boston, which included the historical fact that it did not originate as a Christian holiday. The upper classes in ancient Rome had celebrated December 25th as the birthday of the sun god Mithra, and the date was in the middle of Saturnalia, a month-long holiday that was dedicated to food, drink, and revelry. Pope Julius I was said to have chosen that day to celebrate the birth of Jesus Christ as a way of co-opting the pagan rituals, and thereby create a Christian holiday that also hinged on paganism. However, the Puritans considered it historically inaccurate to place the Messiah's arrival on December 25th, as they believed that Jesus had been born sometime in September.

The Puritans decreed "For preventing disorders arising in several places within this jurisdiction, by reason of some still observing such festivals as were superstitiously kept in other countries, to the great dishonor of God and offence of others, it is therefore ordered by this Court and the authority thereof, that whosoever shall be found observing any such day as Christmas or the like, either by forbearing of labor, feasting, or any other way, upon such accounts as aforesaid, every such person so offending shall pay for every such offense five shillings, as a fine to the country." It

was not so much that Christmas revelry was banned in Boston *"to the great dishonor of God and offence of others"* but that it was a finable offense and five shillings was a considerable sum. As attendance at meeting on Sundays was mandatory in Boston, the ministers, or teachers as they were referred to, and the Ruling Elders, were able to exert control and direction of the residents and to admonish them as to such evilness, and the Puritans outlawed Christmas celebrations entirely in 1659. In fact, the Reverend Cotton Mather lectured his congregation that "the feast of Christ's nativity is spent in reveling, dicing, carding, masking, and in all licentious liberty ... by mad mirth, by long eating, by hard drinking, by lewd gaming, by rude reveling!" Even Judge Samuel Sewall, one of the more stern and upright of Puritans, said in his diary on Christmas morning in 1697, "This morning we read in course the 14, 15, and 16 Psalms ... I took occasion to dehort mine from Christmas-keeping, and charged them to forbear." So Bostonians were to work, and continue in their daily routine on December 25th and were closely watched for any deviance or by the "forbearing of labor, feasting" or any other merriment!

However, after five decades of Puritanical rule in Boston, King Charles II would revoke the charter of the Massachusetts Bay Colony in 1684 after its leaders refused to act on his demands for reforms in the colony, which included religious reforms. In 1686, Sir Edmund Andros was appointed Royal Governor of the Dominion of Massachusetts and as the representative of the monarch in Boston, he was reviled and hated as he restricted town meetings, and promoted the Church of England in Puritan Boston. With the establishment of King's Chapel in Boston in 1686, Anglican services were conducted, and a Bible, silver communion service, cancel table and vestments were given by the monarch. It was undoubtedly the first place Christmas was celebrated in the colony. The Glorious Revolution was to take place in 1689, when King William and Queen Mary, the daughter of James II, were to become co-rulers of Great Britain, which included the colonies in America. Boston saw Sir Edmund Andros imprisoned by Bostonians, and the result was the creation of Province of Massachusetts Bay in 1691, which joined the Massachusetts Bay and Plymouth Bay Colonies as one and instituted broad reforms under the monarchs.

In the eighteenth century, as Boston evolved, it seemed that there was more tolerance of Christmas celebrations, as not only Anglicans but Roman Catholics began to emigrate from Europe. In fact, the first Roman Catholic church in Boston was founded in 1788 by Father de la Poterie at 24 School Street and dedicated as the Holy Cross Church. Here Christmas was celebrated in a Mass on Christmas Eve and on Christmas Day, and began a new transition from the 1659 law banning Christmas. By the early nineteenth century, with a more diverse base of residents in

the Town of Boston, it seemed that the joys of the season were far less restrictive and judgmental. In fact, it was a German immigrant Karl Theodor Christian Friedrich Follen who is credited for introducing the Christmas tree from his native Germany to Boston in the 1830s. Follen and his wife Eliza Lee Cabot Follen lived in Cambridge, as he was a professor at Harvard College, and their Christmas tree attracted the attention of Harriet Martineau during her visit to the United States. The Follens' Germanic custom of a Christmas tree quickly became an indispensable tradition. Surprisingly, the Christmas Tree didn't become popular in Great Britain until Queen Victoria's husband Prince Albert decorated a Christmas Tree at Windsor Castle. A drawing of the event was published in the *Illustrated London News* in 1848, and republished in *Godey's Lady's Book* in 1850, and immediately created a sensation that was taken up as people celebrated with table top trees decorated with gilded eggshells, toys, glass ornaments, cornucopias of sweetmeats and barley candy and wax tapers. Henry Wadsworth Longfellow would note that there was a "transition state about Christmas" in New England in 1856. "The old Puritan feeling prevents it from being a cheerful, hearty holiday; though every year makes it more so," he wrote. Christmas Day was formally declared a federal holiday by President Ulysses S. Grant in 1870 and it was to become a holiday that evolved with traditions of not just decorated trees, wreaths and mistletoe but of foods, cakes and pastries and a multitude of things that people came to associate with the holiday.

Victorian Bostonians embraced the Christmas holiday with alacrity and Louis Prang would publish the first American Christmas card in Boston in 1874, though they had been known in England since 1842. Prang's chromolithographic cards had an individual charm, not just in design but in technique, lettering, the stock used, and their almost perfect coloring, and led to his being referred to as the Father of the Christmas card. Over the next decade, many popular greeting card companies such as Hallmark and Rust Craft produced Christmas cards, and noted artists such as Norman Rockwell, Tasha Tudor, Thomas Nason and even Sir Winston Churchill would design Christmas cards that shared the sender's best wishes at the holidays. Boston in the twentieth century was to see many beloved Christmas traditions that became part of the fabric of life. The Enchanted Village of Saint Nicholas was commissioned by Edward Mitton and created by the Christian Hofmann Company in Coburg, Germany, and opened in 1959 by the Jordan Marsh Department Store. The display would delight generations of children and adults alike with automated figures that created a "mixture of Tudor Revival and storybook style, with half-timbering and mullioned windows that mimicked medieval cottages and English country houses." Seen from the walkways, the snow-covered village houses and shops had

automated figures that peeked from doors and windows to the delight of all. The Boston Christmas Tree on Boston Common is the official Christmas tree of the city and has been illuminated annually since 1941. Since 1971, the tree has been given to the people of Boston by the people of Nova Scotia in thanks for their assistance after the 1917 Halifax Explosion. The City of Boston would also place a Nativity *crèche* on Boston Common with life-sized figures of Mary, Joseph, the baby Jesus, the three Kings, shepherds, sheep and animals recreating the manger scene in Bethlehem. With a small white New England-style chapel where children would sing Christmas carols, statues erected on the Boston Common of Victorian figures singing, the Sermon on the Mount, the Flight to Egypt, the live reindeer kept in a pen along Tremont Street and many others, people would stroll under the trees festooned with colored lights that lined the Boston Common and marvel at the displays.

Christmas Traditions in Boston is a joyful book that revisits our shared memories of the past and brings together the shared tradition of how Bostonians celebrated the holiday season. What could have been better after a day seeing Santa Claus, the Enchanted Village of Saint Nicholas, Handel and Haydn's *Messiah*, the seasonal displays and lights on Boston Common, than to enjoy a hot fudge sundae at Bailey's?

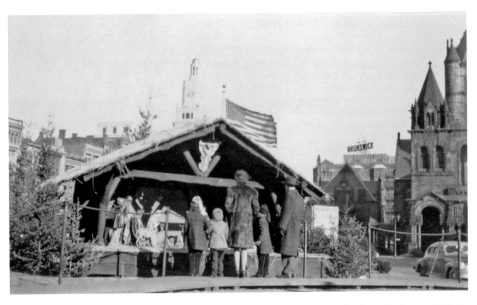

A Nativity *crèche* was erected at Copley Square during World War II on the lawn in front of Trinity Church, seen on the right. The rustic wood manger was surrounded by evergreen trees and a large United States flag flutters in the wind above.

ONE

CHRISTMAS WAS BANNED IN BOSTON!

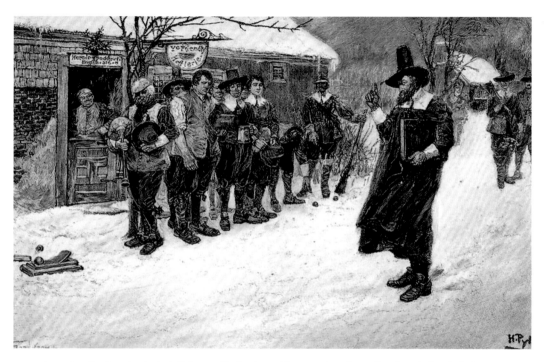

A somber Puritan, in dark clothing and hat, admonishes a cadre of men lined up in front of a tavern after having their ball game interrupted on Christmas Day. The Puritans of Massachusetts Bay were a somber lot and decreed that Christmas would not be celebrated in their colony. It was stated:

> For preventing disorders arising in several places within this jurisdiction, by reason of some still observing such festivals as were superstitiously kept in other countries, to the great dishonor of God and offence of others, it is therefore ordered by this Court and the authority thereof, that whosoever shall be found observing any such day as Christmas or the like, either by forbearing of labor, feasting, or any other way, upon such accounts as aforesaid, every such person so offending shall pay for every such offense five shillings, as a fine to the country.

PUBLICK NOTICE

The Obfervation of Christmas *having been deemed a Sacrilege, the exchanging of Gifts and Greetings, dreffing in Fine Clothing, Feafting and similar Satanical Practices are hereby*

FORBIDDEN

with the Offender liable to a Fine of Five Shillings

A "Publick Notice" was posted in Boston stating that "The observation of Christmas having been deemed a Sacrilege, the exchange of Gifts and Greetings, dressing in Fine Clothing, Feasting and similar Satanical Practices are hereby FORBIDDEN." This was not just an edict of the Puritan church in Boston, but had become a law in 1659, and if one was caught observing these "Satanical Practices," there was a fine of five shillings. Puritans were contemptuous of Christmas, referring to it as "Foolstide" and banning Bostonians from any celebration of it throughout the seventeenth and early eighteenth centuries.

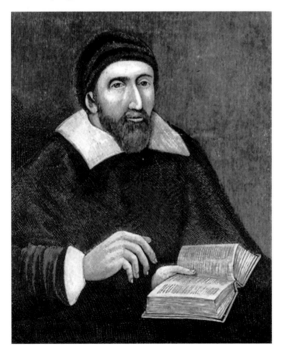

Reverend Richard Mather (1596-1669) was a prominent Puritan Divine who served as teacher, or minister, of the Dorchester Meeting House (now the First Parish in Dorchester, Massachusetts.) Learned and educated, he authored in 1640 the *Bay Psalm Book*, the first book to be published in the New World. As a strict Puritan, though a member of the Church of England who wanted to purify it from within, he banned Christmas from the church calendar. In fact Puritans outlawed Christmas celebrations entirely in 1659 and colonists caught shirking their work duties or feasting were forced to pay a significant penalty of five shillings. Christmas remained banned until the 1680s, when the Crown managed to exert greater control over its subjects in Massachusetts.

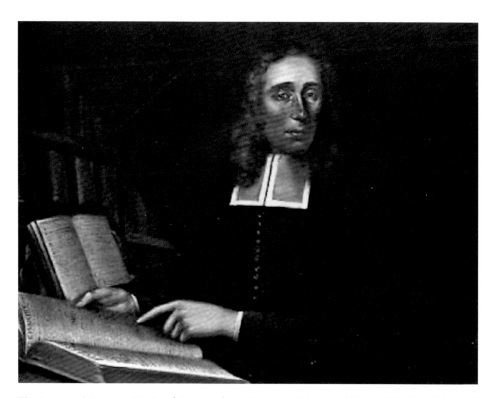

The Reverend Increase Mather (1639-1723) was the son of Reverend Richard Mather. Educated at Harvard College, Mather was a staunch Puritan, opposing anything openly contradictory to, mutually exclusive with, or potentially distracting from his Puritanical religious beliefs. In fact, he sincerely believed that Christmas represented nothing more than a thin Christian veneer on a vulgar pagan celebration and that it was superstitious at best, heretical at worst. He served as the minister at Second Church in Boston from 1664 to 1723 and was involved with the government of the Massachusetts Bay Colony; he served as president of Harvard College from 1685 to 1702.

Samuel Sewall (1652-1730) was a judge in the Province of Massachusetts Bay, best known for his involvement in the Salem witch trials for which he was one of three judges who sentenced people to death, but would later recant and apologize. He served for many years as the chief justice of the Massachusetts Superior Court of Judicature, the province's high court, and kept a detailed diary that recounted the daily occurrences of Boston. On December 25, 1697, he wrote in his diary:

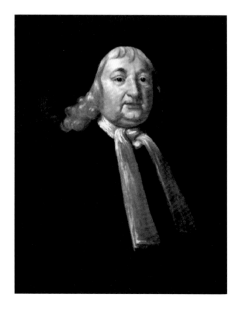

> *Snowy day: Shops are open, and Carts and sleds come to Town with Wood and Fagots as formerly, save what abatement may be allowed on account of the weather. This morning we read in course the 14, 15, and 16 Psalms ... I took occasion to dehort mine from Christmas-keeping, and charged them to forbear.*

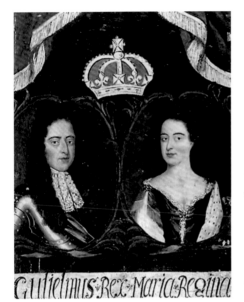

King William III (1650-1702) and Queen Mary II (1662-1694) were rulers of England in the late seventeenth century. William of Orange married his cousin Mary II, the daughter of King James II. The Glorious Revolution of 1689 was to see William and Mary recognized as joint monarchs but also forced them to accept parliamentary limitations on their sovereignty over an empire that began to broaden not only its size but in its tolerance for other religions and nonconformists. As the Province of Massachusetts was part of their colonies in North America, they ruled through a royal governor, but acted as the titular head of the empire.

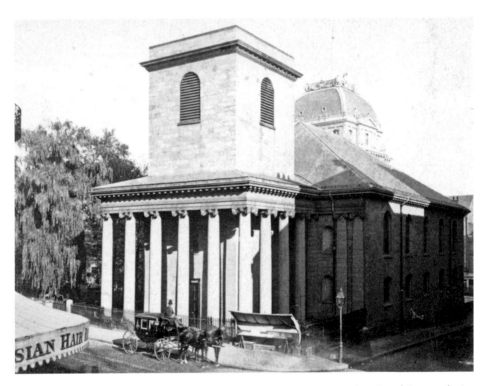

The King's Chapel was founded in 1686 by Royal Governor Sir Edmund Andros (1637-1714), the governor of the Dominion of New England, as the first place of Anglican worship in Massachusetts Bay Colony. The original wood church was replaced in 1754 by a granite church designed by Peter Harrison at the corner of Tremont and School Streets adjacent to the burial ground. It was literally, as an Anglican Church, the "king's" own chapel in Boston, and a Bible, silver communion service, cancel table and vestments were given by the monarch. It was the first place Christmas was celebrated in the colony.

The Reverend Cotton Mather (1663-1728) was the son of Increase Mather and grandson of Richard Mather. A graduate of Harvard College, he was a socially and politically influential Puritan minister at the Second Church in Boston from 1685 to 1728, and prolific author, having written 450 books and pamphlets. His ubiquitous literary works made him one of the most influential religious leaders in America. In 1712 he told his congregation that "the feast of Christ's nativity is spent in reveling, dicing, carding, masking, and in all licentious liberty ... by mad mirth, by long eating, by hard drinking, by lewd gaming, by rude reveling!"

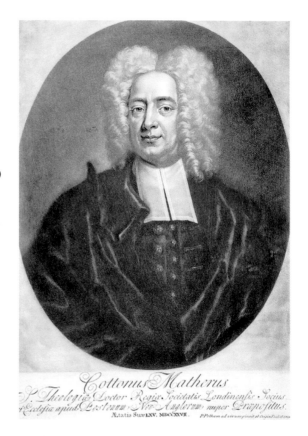

Bishop Jean-Louis A. M. LeFebvre de Cheverus (1768-1836) is one of the more remarkable people in Boston's religious history. Born in France, he served as a priest in his home diocese for six years until fleeing the French Revolution, when he escaped to London and then Boston. He mastered several Indian dialects, served heroically in two yellow fever epidemics, and endeared himself to thousands. He was named bishop of Boston in 1808 and in 1823 he returned to France to become Bishop of Montauban, and then Archbishop of Bordeaux where he received his cardinal's hat.

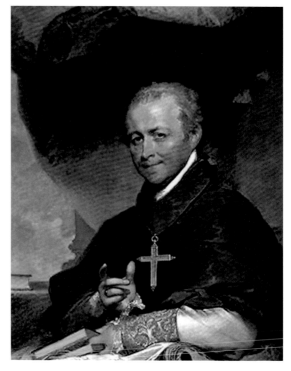

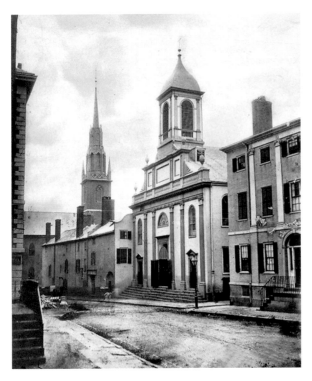

The Cathedral of the Holy Cross was designed by Charles Bulfinch and built in 1803 on Franklin Street, just east of his architecturally impressive Tontine Crescent, seen on the far right, which were the first connected houses to be built in New England. The spire on the left is the Bulfinch-designed Federal Street Church. This was the second Roman Catholic church in Boston, the first founded in 1788 by Father L'Abbe de la Porterie at 24 School Street as the Holy Cross Church. Here Christmas was first celebrated in a Mass on Christmas Eve and on Christmas Day in 1804.

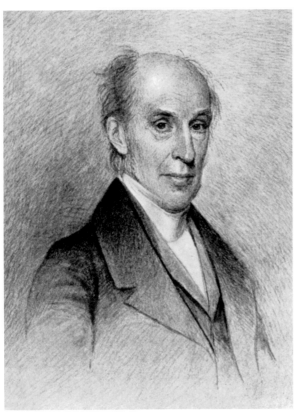

Charles Bulfinch (1763-1844) was a graduate of Harvard College and considered a "Gentleman's Architect" who transformed Boston from a town built of wood into a city built of red brick. Though a Unitarian, Bulfinch's generosity in designing a church for the Roman Catholics in Boston free of charge was to create an ecumenical aspect to the town, especially as it was contributed to by Bostonians of all walks of life.

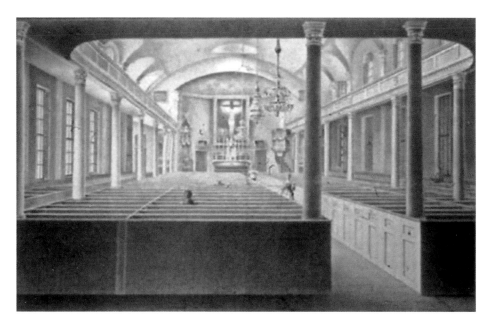

The interior of the Church (later Cathedral) of the Holy Cross on Franklin Street in Boston was much like Bulfinch's previously built meeting houses except there was a consecrated altar with a large painting of the crucifixion of Jesus Christ by Henry Sargent hanging above. Known as *The Christ Crucified*, Sargent was lauded for the painting. He won contemporary favor as he was a prolific painter of portraits and landscapes.

St. Augustine Chapel was designed and built in 1819 by Charles Bulfinch in South Boston on a lot of land purchased on Dorchester Street between West Sixth and Tudor Streets for a mortuary chapel for Father François Matignon and the early priests of the Diocese of Boston. The simple red brick Gothic Revival chapel would eventually be surrounded by the graves of nineteenth century Roman Catholic immigrants who wished to be buried in consecrated ground.

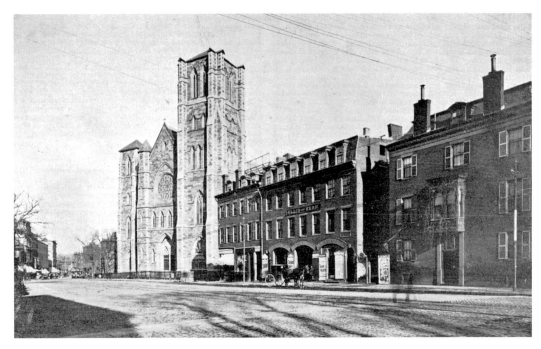

The present Cathedral of the Holy Cross was designed by Patrick J. Keeley, the foremost Catholic architect in the United States, and built in Boston's South End on Washington Street, the former Neck of Boston that connected Boston with Roxbury. Built of Roxbury puddingstone with Quincy granite and sandstone trimming, the building of the early English Gothic style church was begun in 1867 and was consecrated in 1875 as the largest place of worship in New England.

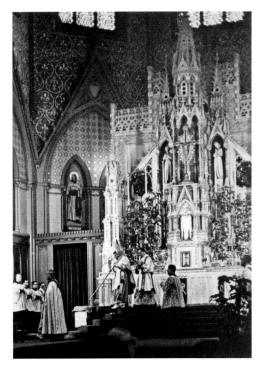

The magnificent altar of the Cathedral of the Holy Cross was designed by Patrick J. Keeley (1816-1896) and carved from white marble. The church interior is impressive, and is divided by lines of bronzed pillars which uphold a lofty clerestory and an open timber roof, and the ceiling and tracery are carved of three shades of oak, and an immense inlaid wood cross adorns the transept ceiling. Seen here during Midnight Mass on Christmas Eve in 1960 with Richard Cardinal Cushing (1895-1970) as celebrant, the altar is decorated with masses of red poinsettias to the Glory of God, and it created a vivid impression on the congregation.

Two

Boston Christmases in the Victorian Era

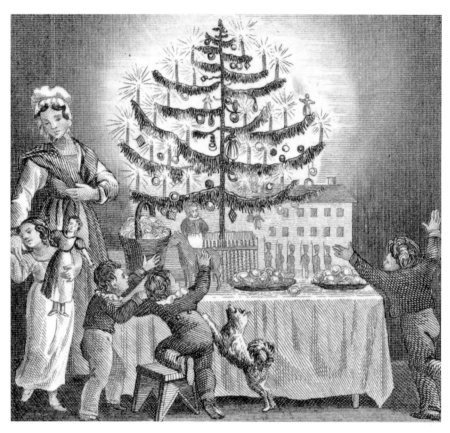

The Christmas trees of the early to mid-nineteenth century were tabletop trees, decorated with small gifts, cornucopias and bags of candy and wax tapers. Here is a mother with her children scrambling about the table, which is covered in a long tablecloth, the tree surrounded by a square picket fence, with baskets and dishes of sweets and fruit as well as a doll house and small solider toys. The dog seems as excited as the children.

Every family assembles all its members together and fathers and mothers are surrounded by their children; they light up a number of wax lights, which they suspend to the branches of a small fir-tree, which are also hung round with the presents they mean to make of them.

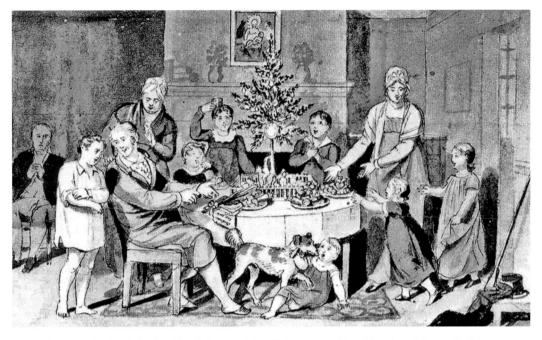

A large family gathering is depicted in 1818 around the dining room table with a tiny table top Christmas tree gracing the center of the table, which is surrounded by a small fence enclosure with animals depicting Noah's Ark within. The family enjoys plates of sweetmeats, fruits and candies that are set around the table. A few years after this image was sketched is the earliest known written reference to the actual phrase "Christmas tree"—which was in 1821, when a father wrote that his children had gone to a local mill "for Christmas trees."

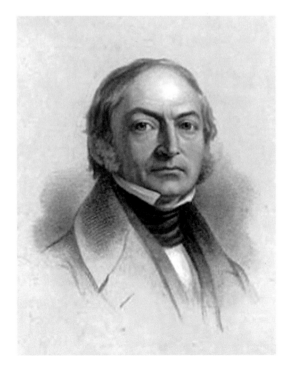

Karl Theodor Christian Friedrich Follen was a German poet and patriot, who moved to the United States and became the first professor of German at Harvard College; he later became a Unitarian minister, and a radical abolitionist. Charles Follen (1796-1840,) as his name was Anglicized, and his wife Eliza Lee Cabot Follen, lived on Follen Street in Cambridge and their Christmas tree attracted the attention of the English writer Harriet Martineau during her visit to the United States. The Follens are credited as the first to introduce the Germanic custom of a decorated Christmas tree to the United States, which has become an indispensable tradition.

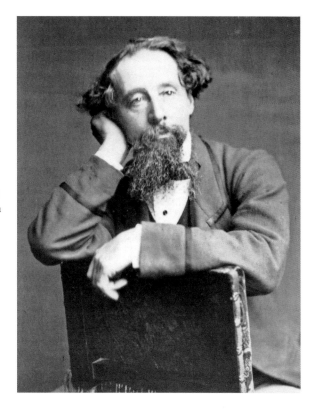

Charles Dickens (1812-1870) was an immensely popular novelist in the nineteenth century and came to Boston where he stayed in a suite at the Parker House. He had first come in 1842 and wrote to a friend that "Boston is what I would have the whole United States to be." Dickens' American publisher, Ticknor and Fields, persuaded Dickens to return in 1867 for a two-year reading tour, and his book *A Christmas Carol* was immensely popular. For the next two years, Dickens treated the Parker House as his home away from home and he practiced for his immensely popular readings in front of a large mirror in his suite.

The Parker House was opened by Harvey Drury Parker (1805-1884) on School Street in Boston. In 1854, a new five-story hotel called "an immense establishment of marble" was designed by William Washburn and it catered to a discerning clientele. The hotel was adjacent to the Massachusetts Horticultural Society headquarters, seen to the left, and opposite King's Chapel and Boston City Hall. Dickens gave a special reading of *A Christmas Carol* at the Parker House to the Saturday Club, which included his American friends: Ralph Waldo Emerson, Henry Wadsworth Longfellow and Oliver Wendell Holmes Sr.

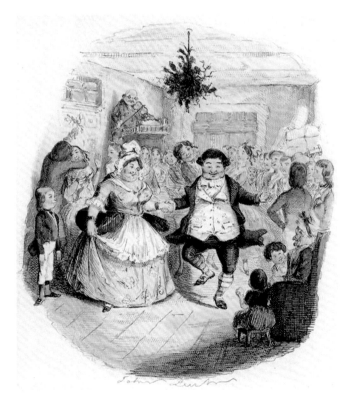

This wonderful etching is of "Mr. Fezziwig's Ball," which was used to illustrate *A Christmas Carol* by Charles Dickens. Mr. Fezziwig, seen dancing with his wife, is depicted as a jovial, if not a foppish man with a large wig, and he is a character from the novel *A Christmas Carol* used to contrast with Ebenezer Scrooge in his attitude towards business ethics. Scrooge, who apprenticed under Fezziwig, is the antithesis of the person he worked for as a young man.

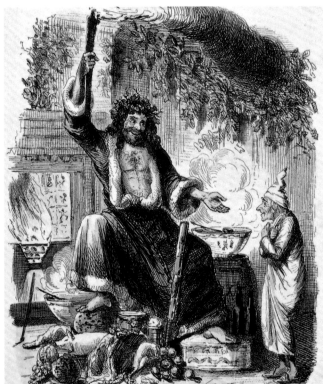

"Scrooge's Third Visitor" is from Charles Dickens' *A Christmas Carol*. Depicted as a burly bare-chested spirit dressed in a simple green robe bordered with white fur and a wreath of holly on his head, he declares, "I am the Ghost of Christmas Present, look upon me!"

"Spirit," said Scrooge, "conduct me where you will. I went forth last night on compulsion, and I learnt a lesson which is working now. To-night, if you have aught to teach me, let me profit by it."

"Touch my robe!" said the spirit, and off they went flying over London. These readings by Dickens when he was in Boston were popular and very well attended.

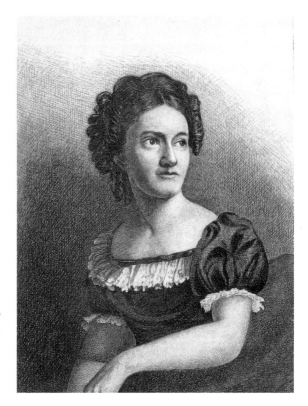

Lydia Maria Child (1802-1880) was the daughter of Converse and Susannah Francis and was born in Medford Square at the corner of Salem and Ashland Streets, where in 1797 her father first baked the famous "Medford crackers." Child was an abolitionist, women's rights activist, novelist and journalist. A noted and prolific author, her book *The Frugal Housewife: Dedicated to Those Who Are Not Ashamed of Economy* was published in 1829, and the book went through numerous reprints due to its popularity as something many Boston women could identify with.

"Grandfather's House," in the popular poem by Lydia Maria Child, was the home of her grandfather at 114 South Street in Medford, Massachusetts. An impressive Greek Revival mansion with monumental Ionic columns was added to the original house of her grandfather Benjamin Francis, and it still faces the Mystic River. In 1844, Lydia Child published the poem "The New-England Boy's Song about Thanksgiving Day" in *Flowers for Children* that became famous as the popular song "Over the River and Through the Wood."

> Over the river, and through the wood,
> To Grandfather's house we go;
> the horse knows the way to carry the sleigh
> through the white and drifted snow.

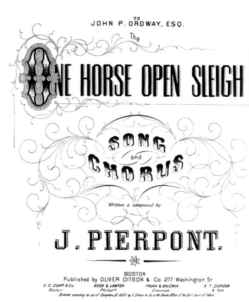

Above left: James Lord Pierpont (1822-1893) was the author of "One Horse Open Sleigh," first published in 1857. It was said that in 1851 Pierpont had gone to the home of Mrs. Otis Waterman to play a piano belonging to William Webber, a Medford music teacher. Mrs. Waterman kept the Seccomb boardinghouse, which became better known later as the Simpson Tavern, on High Street in Medford Square, and it is here that the popular song was believed to have been written.

Above right: The cover of James Lord Pierpont's sheet music for "The One Horse Open Sleigh," or "Jingle Bells" as it is popularly known, was published in 1859 by Oliver Ditson & Company in Boston and was dedicated to John P. Ordway, Esquire.

> Dashing thro' the snow, in a one-horse open sleigh,
> O'er the hills we go, laughing all the way;
> Bells on bob tail ring, making spirits bright,
> Oh what sport to ride and sing a sleighing song to night.
> Jingle bells, Jingle bells, jingle all the way;
> Oh! what joy it is to ride in a one horse open sleigh.

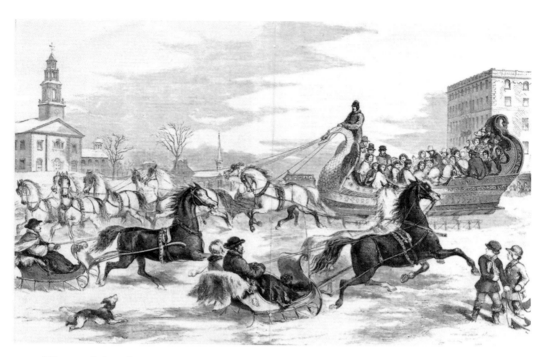

"Cleopatra's Barge" was an enormous eight-horse drawn sleigh that took dozens people on a sleigh ride through Boston and the surrounding towns during the winters of the mid-nineteenth century. Here the "Great Boston Sleigh," with its fantastic gilded-winged swan carved bow, has a man holding the reins as it swiftly glides along Highland Street on Meeting House Hill in Roxbury, Massachusetts, with the First Parish Church on the left and the Norfolk House on the right.

Reverend Phillips Brooks (1835-1893) was the lyricist of the tune "O Little Town of Bethlehem" that was written in 1868 and set to music by L. H. Redner. Brooks was living in Philadelphia at the time but shortly thereafter was appointed minister at Trinity Church in Boston, a prominent church on Summer Street that was destroyed in the Great Boston Fire of 1872. He would later serve as the Episcopal Bishop of the Diocese of Massachusetts and his carol was often sung in churches.

O little town of Bethlehem, how still we see thee lie;
above thy deep and dreamless sleep the silent stars go by.
Yet in thy dark streets shineth the everlasting light;
the hopes and fears of all the years are met in thee tonight.

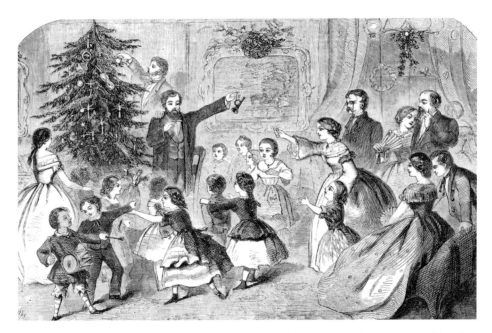

"The Christmas Tree" was depicted in December 25, 1858, by Winslow Homer in an etching that appeared in *Harper's Weekly*. Excited children are seen in the foreground as toys, dolls, trumpets, sweetmeats and hard candies are taken off the tree and distributed to the joyful children. The little boy on the left already received a drum, and he uses the baton to signify his joy as he taps a tune!

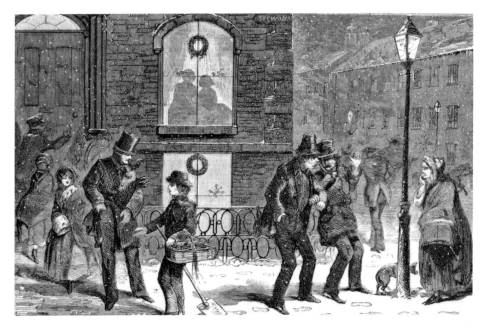

"Christmas Out of Doors" was depicted by Winslow Homer in *Harper's Weekly* on December 25, 1858. It shows street life in the mid-nineteenth century, with a young boy selling chestnuts to a man in a top hat, two men who have enjoyed one too many glasses of punch supporting one another on the icy sidewalk and people walking to see family and friends, whose houses, such as one sees in the center, are decorated with evergreen wreaths with gas light emanating through the window curtains.

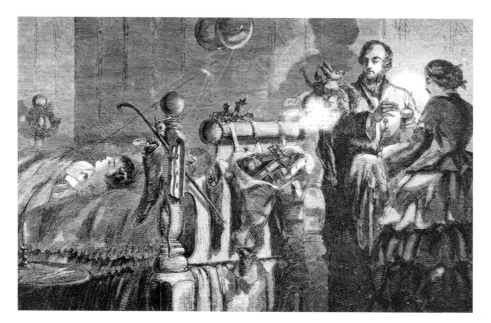

"Santa Claus and His Presents" was depicted by Winslow Homer and appeared in the December 25, 1858, edition of *Harper's Weekly*. A child sleeps in a four-poster bed as his parents fill stockings hung from the headboard with toys, small gifts, candy and fruit. Children around the world who believed in Santa Claus often spent a fitful Christmas Eve trying to stay awake to hear of his arrival in his reindeer-drawn sled, much like today.

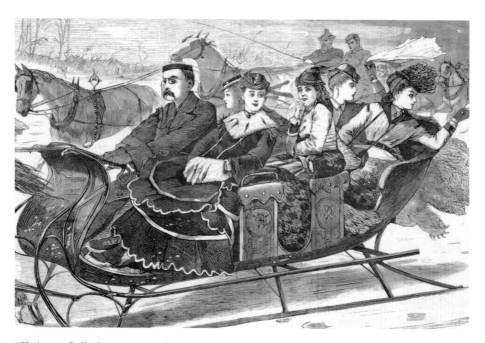

"Christmas Belles" appeared in the January 2, 1869, edition of *Harper's Weekly*, and Winslow Homer depicted well-dressed Boston Belles enjoying a horse-drawn sleigh ride, hoping to see as well as be seen on their ride. Just in case they were not noticed, one belle waves a white handkerchief in the air to a friend in another sleigh. Christmas Bells are ringing as Christmas Belles are sledding!

During the Civil War, many Boston men had enlisted in the Union Army to preserve the Union of the United States. This wonderful print by L. Prang & Company depicts "Christmas in Camp" during Christmas 1864. In the center are soldiers opening boxes that were sent to them by family and friends along with vignettes such as on the left "Christmas Within," with family around a Christmas tree, and on the right "Christmas Without," of those lonely and alone on the holiday.

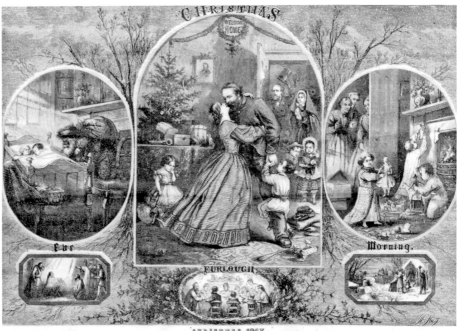

This print by Thomas Nast in *Harper's Weekly* on December 26, 1863, depicts "Christmas 1863" with a couple seen in the center vignette embracing and kissing beneath a wreathed "Welcome Home" sign as he has received a furlough from the Civil War to join his family for the holidays. The left vignette depicts Santa Claus gazing at two children asleep on Christmas Eve and the one on the right on Christmas morning when the children wake to find dolls, small toy horses, toy soldiers and stockings filled with small gifts, fruit and candy.

Thomas Nast (1840-1902) was a prominent political cartoonist in the nineteenth century, and he was considered to be the "Father of the American Cartoon." He was associated with the *New York Illustrated News*, *Frank Leslie's Illustrated News* and *Harper's Weekly* and his cartoons had a wide appeal to the public, and though his Christmas cartoons were charming, as a political cartoonist he would wield more influence than any other artist of the nineteenth century. In 1890, Nast published *Thomas Nast's Christmas Drawings for the Human Race*.

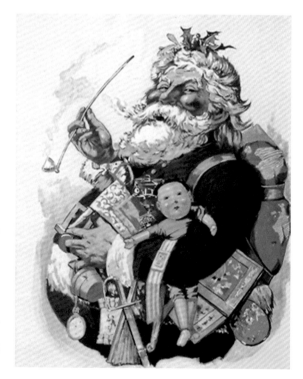

Thomas Nast depicted Santa Claus in this marvelous cartoon of a red cheeked, jolly St. Nicholas holding a long clay pipe, with holly and berries in his hair and an armful of toys including a doll, pail, sword, board games and even a pocket watch to be brought to good boys and girls on Christmas Eve. This cartoon appeared on January 1, 1881, in *Harper's Weekly* and is probably one of Nast's most famous images of Santa Claus.

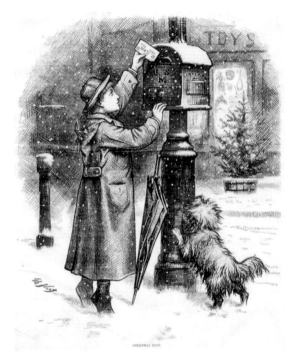

"Christmas Post" was depicted in a cartoon by Thomas Nast in *Harper's Weekly* on January 4, 1879, of a young boy accompanied by his dog posting a letter to Santa Claus. These corner mailboxes in Boston were introduced by Nahum Capen (1804-1886), who served as the postmaster of Boston from 1857 to 1861. Capen placed the iron mail collection boxes throughout the city at his own expense as an experiment, and they proved convenient and turned into an enduring tradition for over a century and a half.

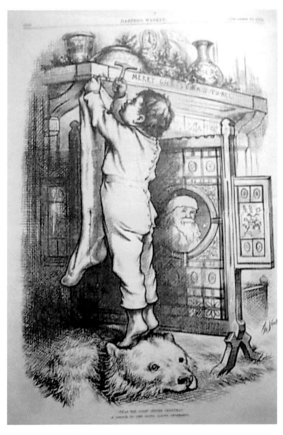

This young boy, in his long johns, stands on the head of a bear rug to gain extra height so he can nail an extremely long stocking to the mantle of the library fireplace. This print, "Twas the Night Before Christmas: A Chance to Test Santa Claus's Generosity" appeared in the December 30, 1876, edition of *Harper's Weekly*. Thomas Nast not only depicted a wonderful fire screen with a profile of Santa Claus, but had "Merry Christmas to All" carved into the mantle.

THREE

A VERY BOSTON CHRISTMAS

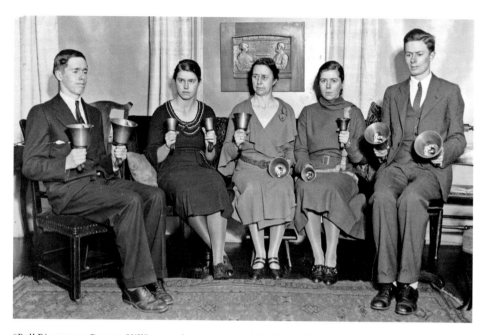

"Bell Ringers on Beacon Hill" were photographed at Christmas in 1931 as they performed a concert of hand bell ringing, which was said to be an almost forgotten form of music. Mrs. Arthur A. Shurcliff, seen in the center, trained her sons and daughters in the art of ringing musical bells in harmony. The Shurcliffs were to be instrumental in introducing their music on Beacon Hill during the holidays, especially on Christmas Eve. Seen in their parlor from left to right are: William Shurcliff, Elizabeth Shurcliff, Margaret Homer Nichols Shurcliff, Sarah Shurcliff and John Shurcliff.

Mrs. Shurcliff said "By 1924 our children were able to ring (the youngest was nine) and on Christmas Eve we started our carol ringing standing in the front yard of 55 Mt. Vernon Street. Our success surprised us."

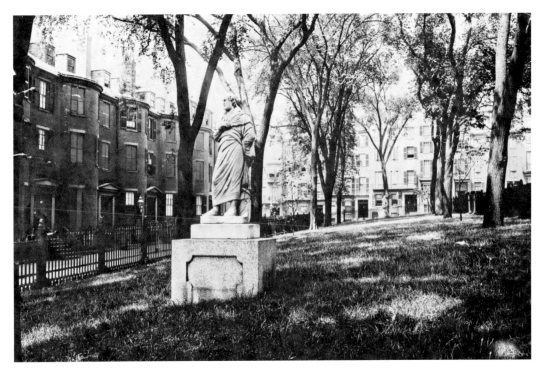

Louisburg Square was laid out as one of two parks on Beacon Hill with swell bay façade red brick row houses built facing the square. The houses were built between 1833 and 1847 and the statues of *Aristides*, seen here, and *Columbus*, to the north, were erected in 1850 and were the gift of the Marquis Niccolo Reggio, an Italian businessman and consul in Boston for the Papal States, Spain, and the kingdoms of Sardinia and of the Two Sicilies. In the early twentieth century, Louisburg Square was to become the location of an annual tradition of music, hand bell ringing and caroling on Christmas Eve.

Christmas Eve on Beacon Hill was written by Richard Bowland Kimball and is a charming story of how the old-time custom of candle lighting and Christmas singing was enacted on Beacon Hill. The beginnings of a Beacon Hill Christmas Eve celebration was described by Malcolm Whelen Greenough:

Beacon Hill was especially delightful at Christmas time when, after a good snowfall, the whole hill took on the look of Dickens's London. Christmas trees were set in living room windows, and the curtains were left open so that passers-by were treated to the glittering splendor of ornaments and myriads of small candles perched in their branches. In basement windows there were candle-lit nativity scenes, known locally as "crèches," adding other, smaller jewels of colored light, so that the whole south side of Beacon Hill glowed richly in the dark with these presentations.

Margaret Homer Nichols Shurcliff (1879-1959), the wife of Arthur Ashael Shurcliff, lived at 66 Mount Vernon Street on Beacon Hill. Seen here, she had a wide selection of handbells as she had played them with her father Dr. Arthur Nichols since her youth, and created a wide following for those who preserved the musical heritage. She was a member of the Ancient Society of College Youths, which is England's oldest and most prestigious bell ringing society. Her father was not only adept at handbell ringing but was also one of the bell ringers at the Old North Church in Boston's North End.

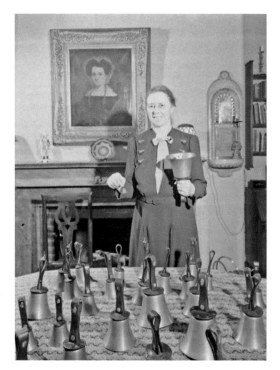

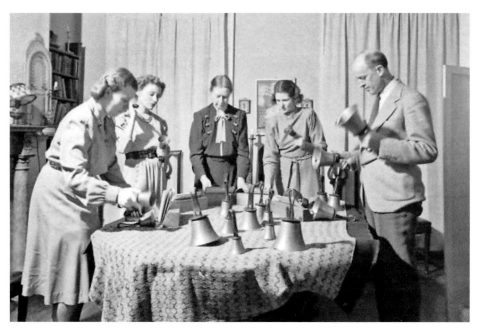

Seen in her dining room, Mrs. Shurcliff is in the center with a small group of friends, and her husband on the far right, who would learn to ring the handbells to create a charming concert. A natural born teacher, Mrs. Shurcliff had patience as well as the skill to encourage so that the person learning how to ring the handbells felt comfortable and was able to progress. In 1937, the New England Guild of English Handbell Ringers was established in the Shurcliff house and she served as the first president; the guild later became known as the American Guild of English Handbell Ringers.

During the early twentieth century, residents of Beacon Hill were encouraged to decorate their homes tastefully and simply to recreate the nineteenth century. Here a doorway on Beacon Street opposite the Boston Common is simply decorated with an evergreen wreath as are the windows, but on Christmas Eve each window would have a lighted wax taper that maintained a long-held tradition.

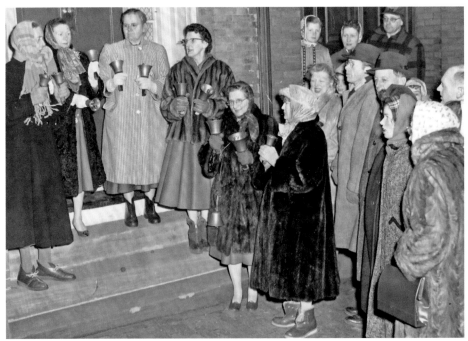

Margaret Homer Nichols Shurcliff, seen on the far left with a head scarf and sensible coat, stands in a doorway on Beacon Hill with a group of fur-clad fellow handbell ringers to perform a musical selection using their handbells. Mrs. Shurcliff was a very proficient handbell ringer but she also encouraged not only members of her family but a wide array of friends to learn the skill. The mini handbell concert was enjoyed by all who traveled to Beacon Hill to hear the music and view the decorated houses.

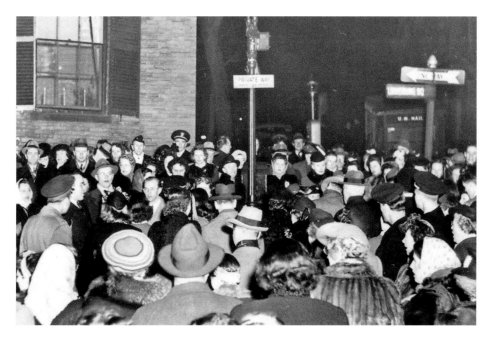

A large group of people gather at the corner of Louisburg Square and Mount Vernon Street on Christmas Eve to join in the signing of Christmas carols. Elizabeth Read Cram, the wife of Ralph Adams Cram, had begun the caroling in 1906, when she first organized a group of carol singers, and it was held from 7:00 to 10:00 PM as a group of singers strolled from place to place on Beacon Hill. It was a festive and joyous time and often residents would have open houses so that people could enjoy a cup of eggnog or punch while warming up and admiring the holiday decorations.

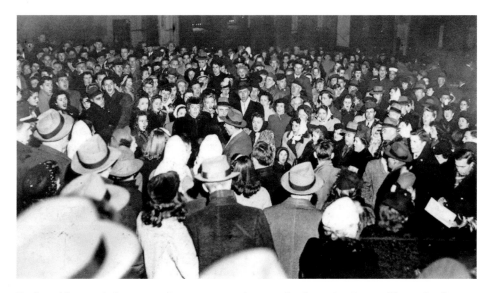

By the mid-twentieth century there were massive crowds of people who would travel to Beacon Hill from all parts of Boston to join in unison in the singing of Christmas carols, and then possibly go to Midnight Mass at a local church. Here the crowd sings a cappella the traditional Boston carols such as "O Come All Ye Faithful," "It Came Upon the Midnight Clear" and Phillips Brooks' "O Little Town of Bethlehem."

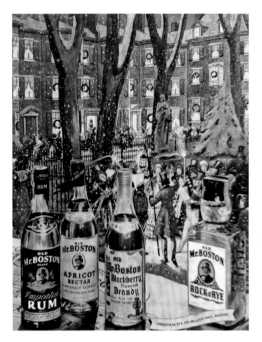

Of course, the tradition of hospitality on Beacon Hill included cups of eggnog and punch for those enjoying the evening. Old Mr. Boston, once a well-known distiller on Massachusetts Avenue in Boston, depicted "Christmas Eve on Beacon Hill" in an advertisement with their Imported Rum, Apricot Nectar, Blackberry-flavored Brandy and their famous Rock & Rye, all of which were to sooth the throats of carolers as well as warm them up if it was an especially cold Christmas Eve!

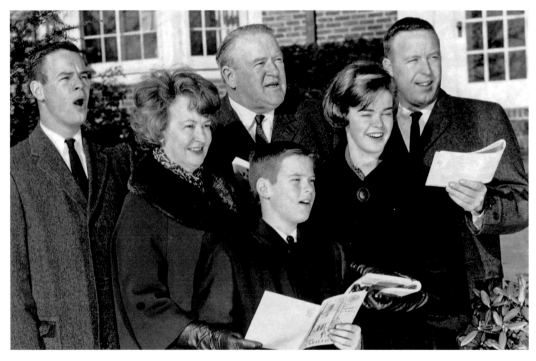

Joseph Cronin (1906-1984,) a well-known and popular member of the Boston Red Sox, and his family Mildred Robertson Cronin, daughter Maureen and sons Thomas, Michael and Hayward continue the tradition of singing Christmas carols. Seen here in December 1961, he had been a Major League Baseball shortstop, manager and general manager. He also served as president of the American League for fourteen years. From 1926 to 1945 he played for three different teams, primarily for the Boston Red Sox, and he was elected to the Baseball Hall of Fame in 1956.

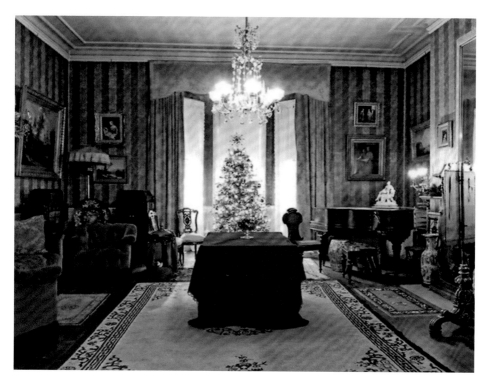

The Gibson House Museum, built in 1859 and one of the first buildings built in the newly created Back Bay of Boston, is a house museum at 137 Beacon Street. Charles Hammond Gibson, Jr. (1874-1954) left his family townhouse as a rare survivor of how a Boston Brahmin family had lived, as he was the third generation to have lived in the house as well as the last family member before it became a house museum in 1957. Today, the family Christmas tree is set in the rear oriel of the Music Room and is decorated as one might expect for the late nineteenth century.

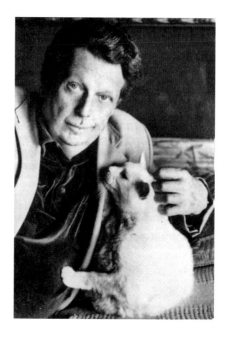

Cleveland Amory (1917-1998,) seen here with his beloved cat Polar Bear, wrote the perennially popular series of books *The Cat Who Came for Christmas*. Following his scathing book *Who Killed Society?* as a sequel to *The Proper Bostonians*.

Amory became a well-known author, reporter and social arbiter but he was best known for his bestselling books about his adopted cat, Polar Bear, starting in 1987 with *The Cat Who Came for Christmas*. Devoting much of his life to promoting animal rights, the executive director of the Humane Society of the United States described Amory as "the founding father of the modern animal protection movement."

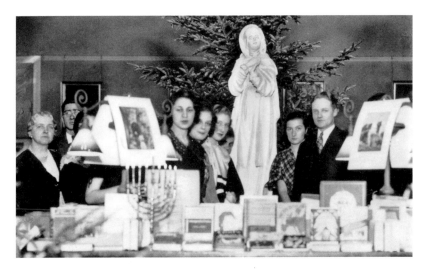

The West End Branch of the Boston Public Library was once located in the former Old West Church at the corner of Cambridge and Lynde Streets in Boston's West End. This neighborhood was one of the most diverse in the city with many ethnic and racial groups living in a densely built up area. The library staff, seen here in 1932, often created festive displays in December that not only included a statue of the Virgin Mary with evergreen trees placed throughout the library, but also menorahs as there was a large population of Jews in the West End of Boston. This ecumenical spirit pervaded the enjoyment of the holidays by the entire neighborhood.

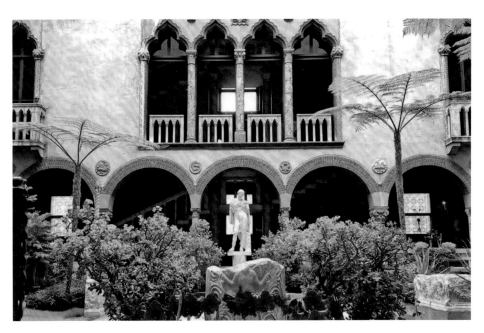

"Fenway Court" was designed by Willard T. Sears for the great Boston art collector Isabella Stewart Gardner (1840-1924) and opened on New Year's 1903. She had acquired architectural details, fragments and even whole facades on her worldwide travels and she would build a fantastic palace in the Fenway section of Boston where she created museum-like settings for her world-renowned art collection. The courtyard of her home has long been a lush oasis during Boston winters, but the greens and an incredible array of amaryllis and poinsettias at Christmas is legendary.

The Cathedral of the Holy Cross was designed by Patrick J. Keeley, the foremost Catholic architect in nineteenth-century America, and built on Washington Street between Union Park and Melrose Streets in Boston's South End. Built of Roxbury puddingstone, its massive composition was envisioned as having two towers on either side of the facade, but their projected weight would not have been supported by the land upon which the church was built. The cathedral continued the simple nineteenth-century Christmas decorations, but on a more lavish and massive scale.

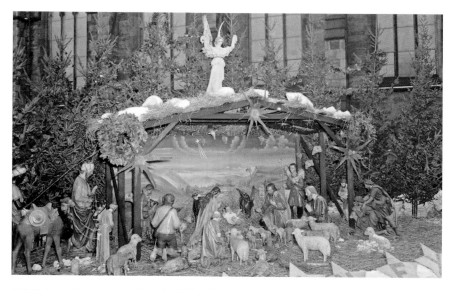

A Nativity *crèche* was erected on the Union Park Street side of the Cathedral of the Holy Cross annually. The manger was built as a simple wood-framed open shed but the polychromatic life-sized figures as well as the painting on the back wall were impressive. Surrounded by a wall of evergreen trees and an angel surmounting the roof of the manger, it was admired by parishioners, neighborhood residents and school children on a daily basis during the holiday season.

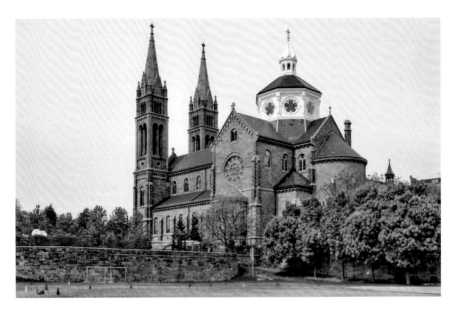

Our Lady of Perpetual Hope was opened by the Redemptorist Fathers on Tremont Street in Roxbury as a Romanesque Revival church designed by William Schickel and Isaac Ditmars and constructed of locally quarried Roxbury puddingstone. The soaring twin towers were designed by F. Joseph Untersee and built in 1910 and can still be seen from their lofty elevation known as Mission Hill. In 1954, Pope Pius XII named the church a minor basilica, a designation reserved for churches with exceptional architectural merit, a large following and historical significance as a center of worship in a particular community. In the case of the Mission Church, the miracles attributed to the shrine contributed to the elevation of its status.

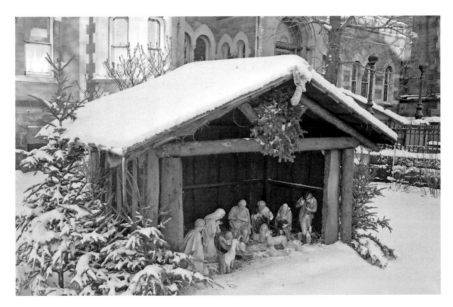

The Nativity *crèche* at Our Lady of Perpetual Hope was erected in front of the Rectory on Tremont Street. Built of stout wood logs that supported a solid wood roof, the life-sized figures were placed so that those walking along Tremont Street could stop and pay reverence or say a prayer.

FOUR

BOSTON COMMON AT CHRISTMAS

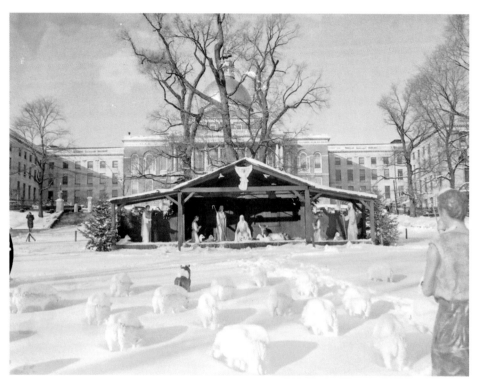

Christmas is the celebration of the birth of Jesus, and the word nativity comes from the Latin word "natal," which means birth. The Nativity *crèche* on Boston Common was an annual tradition that brought thousands of people to view the life-sized figures of Mary, Joseph, the baby Jesus Christ and the Three Wise Men along with angels, shepherd boys and flocks of sheep. Here in 1955, the manger scene was gently covered by a recent snowfall and was framed by the Massachusetts State House on Beacon Hill in the distance.

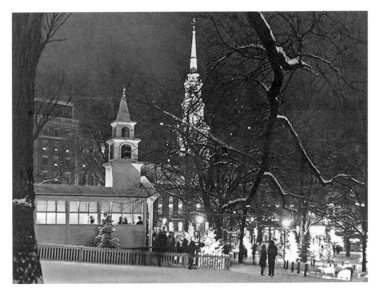

A small chapel, which was a remodeling of the former Buddies Club from World War II that was on Boston Common opposite West Street, was erected on the Boston Common near the kiosk to Park Street Station seen on the far right. This small white New England chapel, replete with a two-tier steeple with amplifiers, was booked by Boston area school glee clubs and church choirs that would present Christmas music programs to the delight of the public. In the distance is the spire of the Park Street Church at the corner of Tremont and Park Streets.

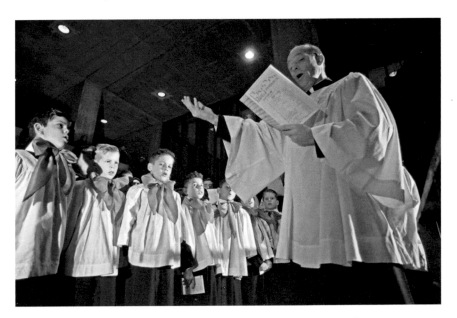

At a 1969 concert at Boston City Hall, Theodore Norbert Marier (1912-2001) directs the young boy's choir who were students at the Boston Archdiocesan Choir School that was located at St. Paul's Church in Harvard Square, Cambridge, Massachusetts. Marier was organist and choir director at St. Paul's Church in Cambridge and the boys of the Boston Archdiocesan Choir School were dressed in white cassocks over black robes with enormous red bows at their necks. Their voices were considered to be among the finest in the Archdiocese of Boston.

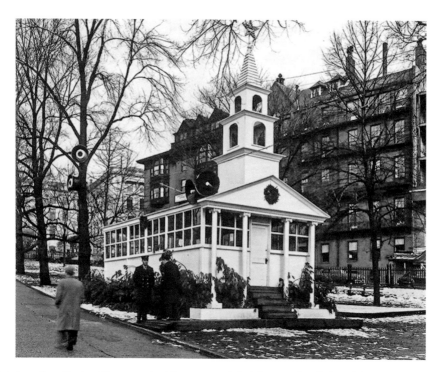

The chapel on Boston Common had been remodeled from a simple box-like clubhouse used previously for a servicemen's canteen. With a new center entrance flanked by thin Ionic columns, it looked like a miniature New England meeting house. John Goode remembered that he "went to see a high school music group [there] one year that included my cousin. They sang outside because the weather was nice, but they could have sung inside the 'church' if it wasn't. There was an organ inside and the speakers carried the music and the voices throughout that part of the Common."

Karen MacInnis was raised in Reading and attended the Congregational Church and was a member of the Herald Choir from 4th grade through junior high. The choir sang at the chapel on Boston Common a few times and she remember that "it had a tar paper floor. It was nearly impossible to step or move in the chapel without making a noise because of the grit on the tar paper. The woman who played the organ and gave the instructions was VERY specific about the rules and regulations!! She had a large toggle switch that she would flip which turned on all of the outside speakers. Imagine the chapel full of us hyper kids, squished in the building with our coats on and holding our little music booklets preparing to sing on the Boston Common. We would wiggle like a can of worms!! Then, the woman would tell us in no uncertain terms that once she flipped that switch we were NOT TO MOVE. She would introduce us and we would sing but we couldn't move."

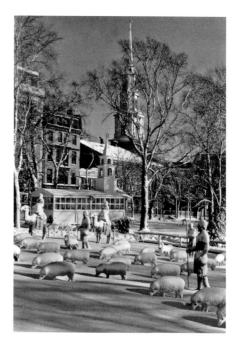

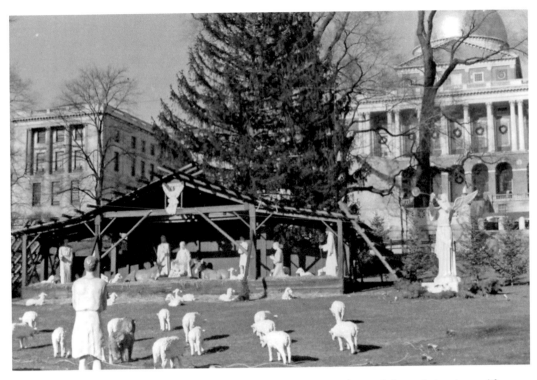

The manger at the Nativity *crèche* at the Boston Common was a simple wood-framed structure with wood posts supporting the open roof and a platform that was covered in straw upon which the life-sized statues were placed. Notice the simple evergreen wreaths on the State House windows in the distance. One can almost imagine the carol "Away in a Manger" being sung:

> Away in a manger, no crib for a bed,
> The little Lord Jesus laid down His sweet head;
> The Stars in the sky, looking down where He lay,
> The little Lord Jesus, asleep in the hay.

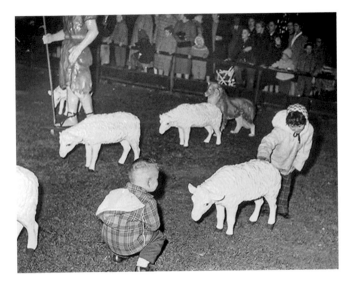

These children have slipped under the stanchions along the edge of the walkway at the Boston Common to inspect the white sheep that were a part of the Nativity *crèche*. The large number of people—adults, young adults and children—lined up along the walkways, and the turnout to view the *crèche* was tremendous during the season.

The Three Wise Men on their camels can be seen on the right approaching the Nativity *crèche*. In the carol "We Three Kings of Orient Are":

We three Kings of Orient are, bearing gifts we traverse afar
Field and fountain, moor and mountain, following yonder star

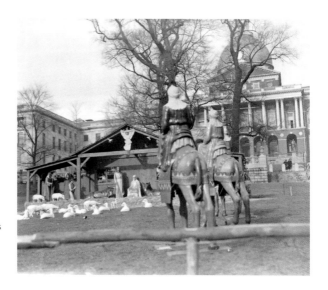

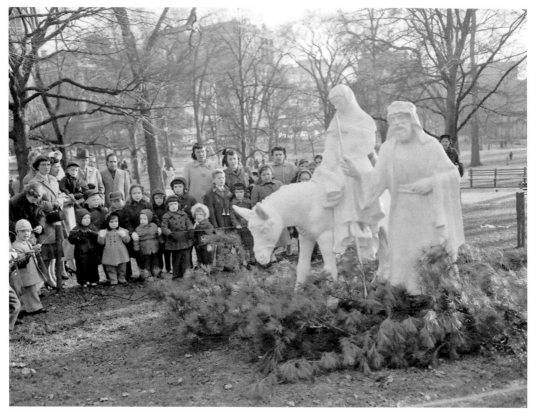

These white fiberglass statues depict Mary, Joseph and the baby Jesus leaving Bethlehem after the birth in the manger. The Bible tells of the Flight to Egypt from Bethlehem as Herod had decreed that every newborn male child was to be massacred; an angel appeared to Joseph in a dream to tell him to flee to Egypt with Mary and infant son Jesus. Tirone Studios produced these statues in weather-resistant fiberglass and the young children, their parents and grandparents look upon the scene with awe and reverence, remembering the stories often retold at Sunday School.

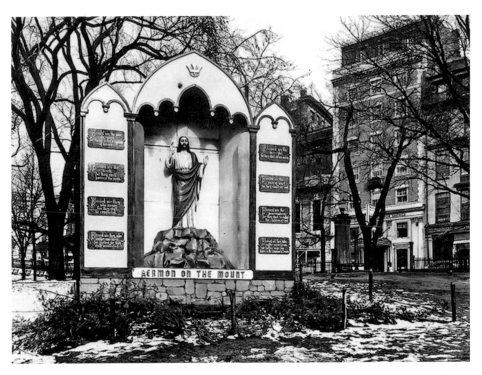

The Sermon on the Mount was a large shrine with open doors that had a life-sized statue of Jesus Christ standing on a depiction of rocks on the mount. The Sermon on the Mount is a collection of sayings and teachings of Jesus Christ, which emphasizes his moral teaching found in the Gospel of Matthew, and is the longest continuous section of Jesus' teachings found in the New Testament.

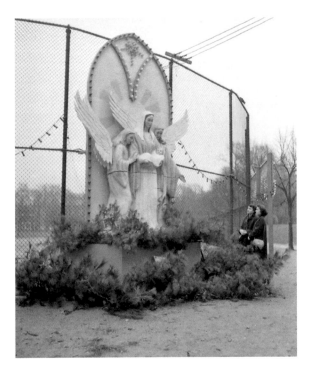

Two young women gaze up at an enormous tableau of the Virgin Mary holding the baby Jesus Christ flanked by winged angels in 1952. With electric lights surrounding the tableau and strings of electric lights draped as swags on the chain link fence of the baseball field on the edge of Boston Common, this was on the far side near the entrance at Boylston and Charles Streets.

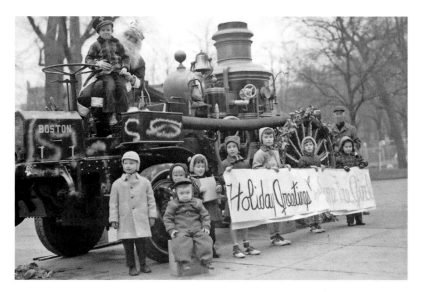

Santa Claus often came to the Boston Common in the weeks leading up to Christmas to greet the children of Boston on an old Hunneman Steam Engine, provided courtesy of the Boston Fire Department. Santa Claus sits on the engine with a young boy on his lap wearing the hat of a firefighter, as young children in the foreground hold a banner proclaiming "Holiday Greetings."

Just a line from Santa to tell you I am looking up all the little boys and girls I will call upon, so if you want me to stop at your house you must be a real good child.

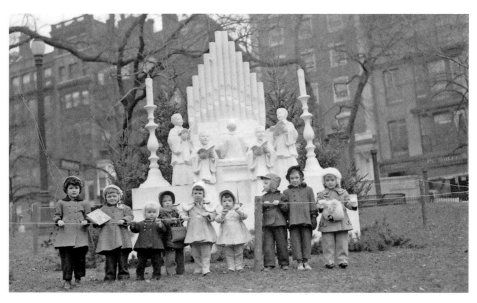

Young children pose in front of a white fiberglass statue depicting an organist and a choir along with the organ pipes flanked by larger-than-life candlesticks.

These weather-resistant fiberglass statues were created by Tirone Studios, with George Tirone, Luigi Mucci and Joseph Bertucci producing them for the city of Boston. In the distance is Park Street that runs parallel to Boston Common, and had not just the Paulist Center, but numerous business concerns in the twentieth century.

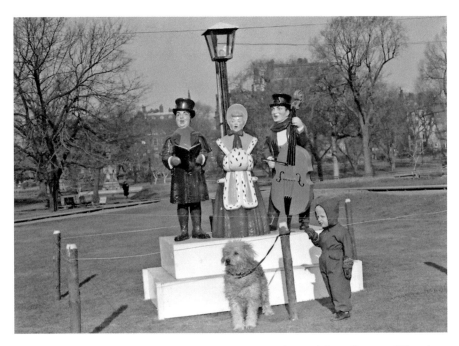

A young boy in his winter snowsuit with his dog pose in front of three figures of Victorian-garbed singers and a bass viol player on the right. Set on a two-stepped wood platform, the electric street lamp was illuminated in the evening and all of the trees in the distance were draped with multi-colored electric lights that lined the walkways of Boston Common and created a magical aspect as one walked around the city.

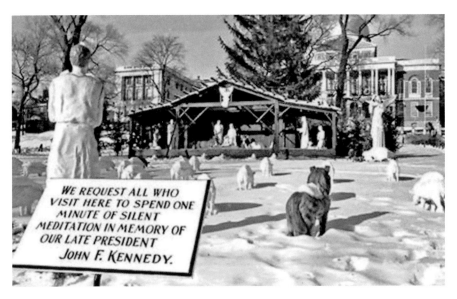

In December of 1963, a sign was erected at the edge of the Nativity *crèche* on Boston Common after the assassination of President John Fitzgerald Kennedy, which had occurred the month previous. The shock of the assassination was still something that many fellow Bostonians felt and the sign asked, "We request all who visit here to spend one minute of silent meditation in memory of our late president John F. Kennedy."

FIVE

CHRISTMAS CARDS, CAROLS & SEASON'S GREETINGS

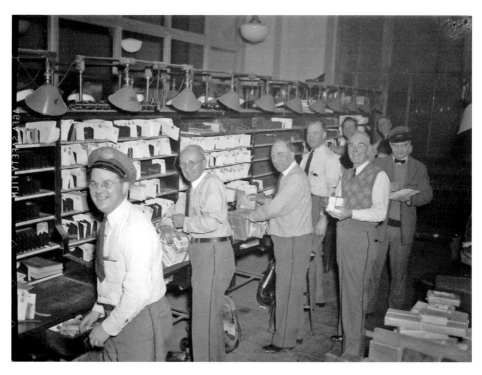

Christmas cards and Christmas presents have been sent through the postal service since the mid-nineteenth century, but by the mid-twentieth century, it seemed that families would receive hundreds of Christmas cards from family and friends. Here, the Boston Post Office had to hire additional help to sort the huge increase in volume during the month of December, and it seemed that it was done by a group of smiling postal workers!

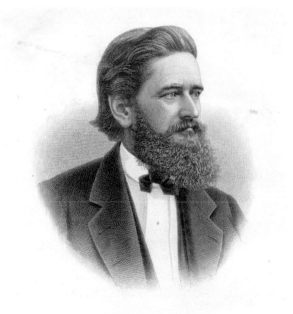

Louis Prang (1824-1909) is considered the Father of the Christmas card as in 1874 he published the first American Christmas card, though they had been known in England since 1842. A native of Breslau, Germany, he was to not only produce the first Christmas cards in the United States but it was said during his lifetime that "His cards had an individual charm, not merely in design but in technique, lettering, the stock used, and their almost perfect coloring."

The home of Louis Prang is at 45 Centre Street in Roxbury, Massachusetts, a neighborhood of the city that was once an independent city until 1868 when it was annexed to Boston. On the far left can be seen a portion of the Prang Factory at Roxbury and Gardner Streets where he and a cadre of skilled chromolithographers produced not just Christmas cards but reproductions of oil paintings and landscapes that were considered "so perfect that oft-times an expert could not distinguish them from the originals."

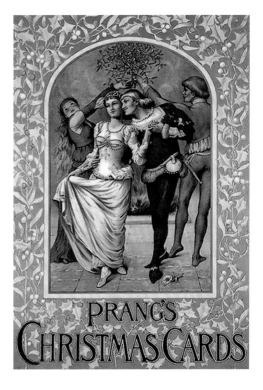

This is an 1864 chromolithograph of "A Visit from St. Nicholas" which was published by L. Prang & Co. and shows a somewhat severe Santa Claus emerging from a fireplace with a doll, a toy soldier and a stuffed animal in his hands. At that time Louis Prang's Studio was at 159 Washington Street in Boston before it was moved to Roxbury. Clement Clarke Moore's 1822 poem, "A Visit from St. Nicholas," introduced Santa Claus into American lore.

Prang's Christmas Cards, seen here in a late nineteenth-century chromolithograph, were not just artistic but "were recognized all over the world for their excellence of design and reproduction." Probably the finest Christmas cards available at the time, they have now become wonderful examples of his skill as a chromolithographer.

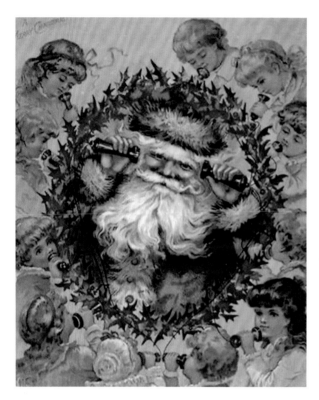

This chromolithograph Christmas card depicts a holly-wreathed Santa Claus in the center holding telephone receiving tubes to both ears as children with speaking tubes tell him of their wishes for toys, games and gifts that they hoped would be brought by him on Christmas Eve.

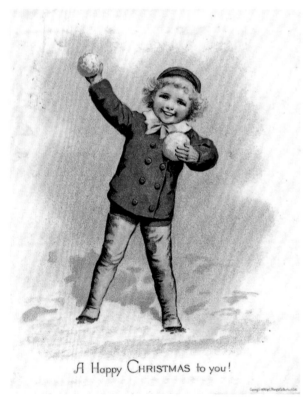

A Happy CHRISTMAS to you!

"A Happy Christmas to you!" depicted a young boy in 1885 tossing snowballs by Louis Prang on this Christmas card. The smiling young boy was depicted with an individual charm that often made the recipient not just think of the sender fondly, but made them smile for the artistic quality of the design.

This adorable chromolithograph depicts a young bonneted child with Santa Claus in his reindeer-drawn sled in the background, all encircled by sleigh bells. As the Christmas card says:

> Away, away! To my loved away; Fly to my
> darling, and greet her to-day;
> Tell her I send her a love and devotion,
> Wide as the world is, and deep as the ocean.

These cards were considered to be as good, if not the best, that were published anywhere.

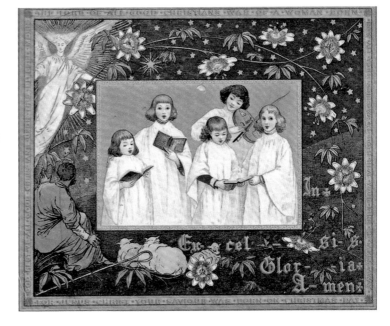

A group of young choirboys in flowing white robes sing the joys of the season accompanied by a boy playing a violin. This Christmas card, with an angel and shepherd with his crook and sheep on the left, extols, "In Excelsis Gloria. Amen."

In the top of the border are the words "The Lord of all good Christmas was of a woman born". Right side, "Now all your sorrows he doth heal your sins he taketh away". Left side "God rest ye all good Christians upon this blessed morn". At the foot "For Jesus Christ your savior was born on Christmas Day." Louis Prang perfected the technique of chromolithography to a point that perhaps never before or since has been equaled.

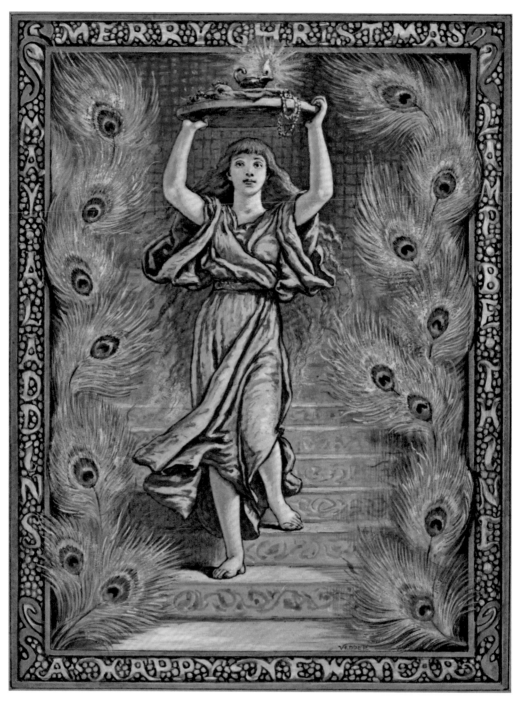

Probably one of the most impressive chromolithographs Louis Prang ever produced was this Christmas card depicting a young maiden descending a staircase and holding a lighted lamp above with peacock feathers flanking her. The card was designed by Elihu Vedder and sent Merry Christmas greetings as well as wishes for a Happy New Year, but it also stated "May Aladdin's Lamp Be Thine" as by rubbing an oil lamp would summon the genie dwelling in it. This Christmas card was awarded a prize by Louis Prang who "gave as much as two thousand dollars as first prize for an original" design.

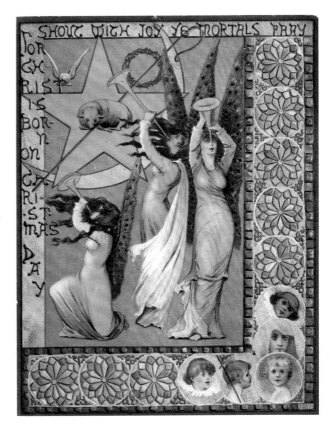

Elihu Vedder (1836-1923) was a symbolist painter, book illustrator, and poet and one of the many artists who won competitions in designing Christmas cards for Louis Prang. "Prang was fully aware that beautiful design as well as reproduction was foremost in creating greeting cards and he originated the idea of giving valuable prizes for Christmas card designs," of which Vedder was a multiple winner.

This chromolithograph of a Louis Prang card, also designed by Elihu Vedder, had an almost mosaic-like quality to it, depicting three diaphanous gowned winged angels with trumpets blowing forth to the entire world to "Show with joy ye mortals pray for Christ is born on Christmas Day." Prang's cards had an individual charm, not just in their design but in technique, lettering, the stock used, and their almost perfect coloring.

Hark! The herald angels sing Glory
to the newborn King!
Peace on earth and mercy mild, God
and sinners reconciled!

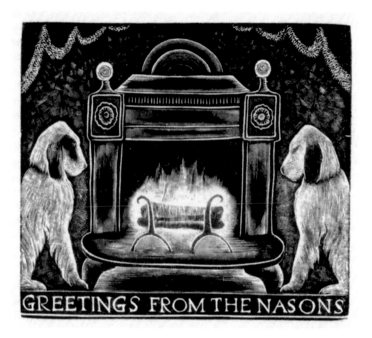

GREETINGS FROM THE NASONS

Thomas Willoughby Nason (1885-1971) was a well-known artist who designed a woodcut Christmas card of his dogs artistically flanking a Franklin stove with a roaring fire that shared Christmas "Greetings from the Nasons." In the early 1920s, his interest in art led him to explore and learn wood engraving and printmaking, and he would pursue his craft for the next 40 years. His prints are devoted to the portrayal of the New England landscape with remarkable sensitivity and detail.

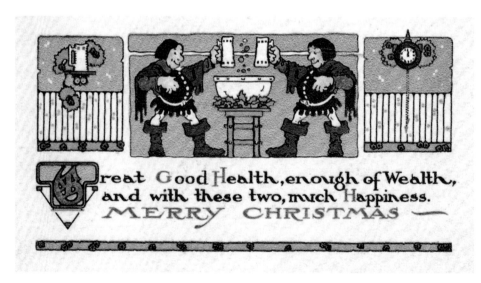

Great Good Health, enough of Wealth, and with these two, much Happiness. MERRY CHRISTMAS —

A 1913 Christmas card produced by the A. M. Davis Company depicted two medieval knights holding tankards of punch aloft as the card offers "Great Good Health, enough Wealth, and with these two, much Happiness." Started by Albert M. Davis in Boston, his cards had an Art and Crafts look with text in distinctive typefaces and decorative borders. It was said that Davis had "a keen sense of what made a good card verse, an uncanny gift in the selection of assistants, and a business judgment which kept him for many years one of the foremost men in the industry."

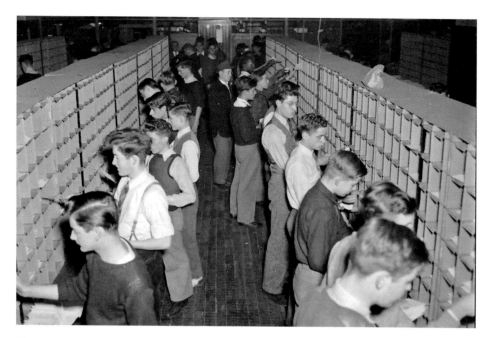

The Boston Post Office was literally inundated by a huge increase in the sorting and delivery of Christmas cards in the twentieth century. To alleviate the burden on postal employees, part-time seasonal help, such as these young men, were hired during the holiday season to help sort and prepare the large number of Christmas cards and letters in the four weeks after Thanksgiving.

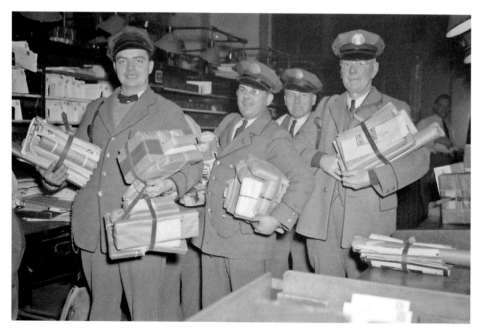

It was not just Christmas cards that postal employees delivered, but wrapped packages as well as rolled calendars for the upcoming year that were often sent to clients through the postal system. These four postmen, laden with armfuls of mail and packages, still manage a smile before they depart the post office to begin their morning deliveries.

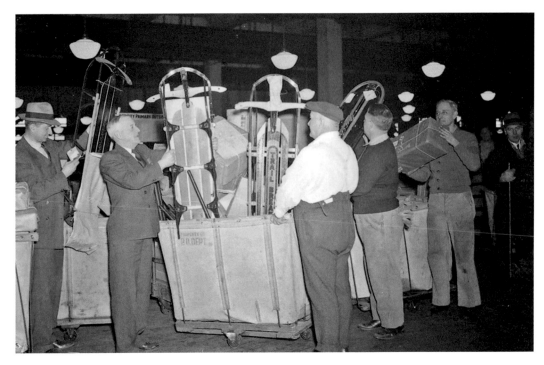

It was not just Christmas cards and packages that were sent through the post office, but larger items such as these sleds that are in canvas bins awaiting delivery. The man, second from the left, inspecting this Flexible Flyer Steel Runner sled, is the author's cousin, Patrick J. Connolly (1876-1955), who served as postmaster general of Boston from 1943 to 1948.

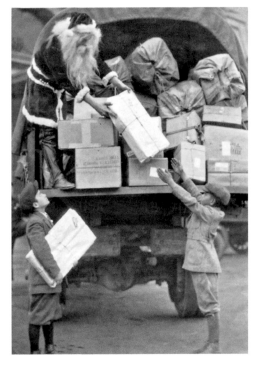

Sometimes, especially in the week before Christmas, there was so much mail and packages that even Santa Claus had to lend a hand in their delivery! Here, Santa Claus gets on the back of a delivery truck and hands packages to two young boys.

Rust Craft Greeting Card Company was a popular and well-known greeting card company that was started by Fred Winslow Rust in 1906 as a bookshop in Kansas City, Missouri. Rust Craft produced "Enchanting Cherub Christmas Cards" that they said everybody wanted! Fred Rust was later to be joined by his brother Donald Rust and their cards "always strove to maintain the highest standards in design, reproduction and composition." Rust Craft revolutionized the use of the "French Fold," a method of folding paper into quarters in order to print a card on a single sheet of paper with a single printed side. Fred and his staff wrote many of the most popular messages. Located in Boston's South End, it moved to Rustcraft Road in Dedham, Massachusetts, in 1954.

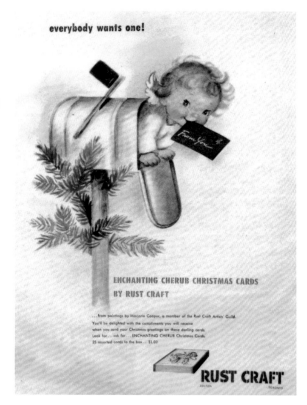

This 1947 Rust Craft Christmas card depicted an old-fashioned English village scene with carolers strolling down a snowy street that sent "Christmas Greetings from Your Friends." Fred Winslow Rust (1877-1949) was a great admirer of Louis Prang and his cards and was said to be "influenced by the skill and beauty of their reproduction," and carried that to his own card company.

> Just to bring a Christmas greeting
> From a friend who can't forget
> That a good old fashioned friendship
> Is the best of all things yet.

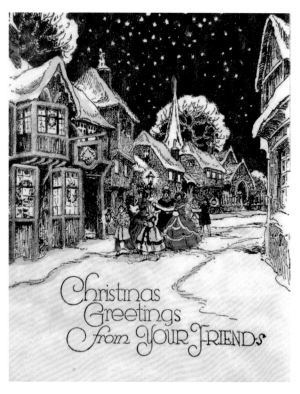

Tasha Tudor (1915-2008) was a fascinating artist and author whose Christmas cards evoked an old fashioned quality and charm of home life. Born Starling Burgess, she was the daughter of naval architect W. Starling Burgess, known as "the Skipper" and noted portrait painter Rosamond Tudor. She took the name Tasha (short for Natasha as she was called by her nanny) and after her parents' divorce, would marry Thomas McCready, and they raised their family on a farm in New Hampshire. A Boston Brahmin, Mrs. Tudor embraced the life of the nineteenth century, dressing in the fashion of the 1830s, and she evoked a sense of history in her home. Tasha Tudor illustrated almost 100 books, the last being *Corgiville Christmas*, released in 2003.

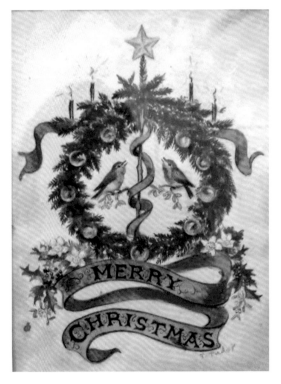

An early Christmas card designed by Tasha Tudor in the late 1940s had an evergreen wreath surmounted by a gold star and lighted wax tapers as two birds perch on twin branches. Colorful, almost classical in its design, it sent "Merry Christmas" greetings to the recipient.

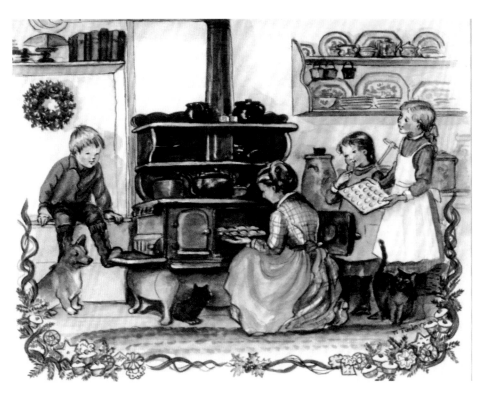

Tasha Tudor's Christmas cards were wonderful family depictions such as this one of a mother baking cookies in an old-fashioned cast iron stove surrounded by her son and daughters as well as the family pets. These interior scenes on her Christmas cards also depict a wall shelf with Canton china and a decidedly New England-themed kitchen.

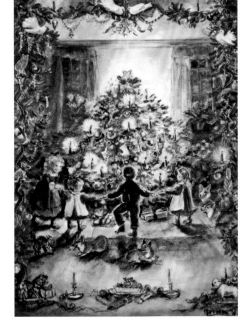

A group of children hold hands as they dance around the illuminated Christmas tree in this Tasha Tudor Christmas card from the 1960s. The children are dressed in typical nineteenth century outfits, the living room includes her favorite corgis in the foreground as well as white doves and swags of evergreen festooned with toys, animals and wax tapers.

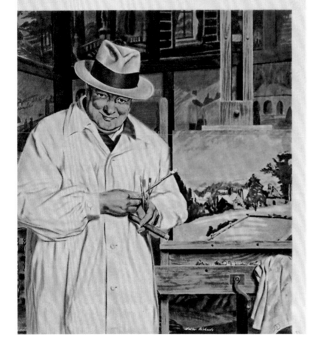

Hallmark Christmas Cards now present the paintings of the Right Honourable

Hallmark Christmas Cards have long been a tradition in Boston, and in the late 1950s, Hallmark was fortunate in securing the use of winter-themed paintings done by the Right Honorable Winston Leonard Spencer-Churchill (1874-1965), who served as prime minister of Great Britain from 1940 to 1945 and again from 1951 to 1955, on their Christmas cards. Here, seen in an artist's coat over his suit and his trademark fedora, Churchill was an accomplished amateur artist and took great pleasure in painting as he holds his artist's brushes with a winter-themed painting on his easel.

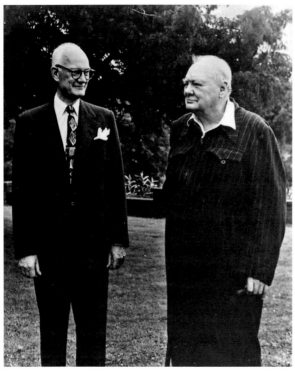

Joyce Clyde Hall (1891-1982,) on the left, was the founder of Hallmark Cards, and Winston Spencer Churchill was an artist commissioned to paint Christmas scenes for cards in the late 1950s. Hall founded his card company in 1910, and so popular were his cards that his staff was increased. They not only produced holiday cards but everyday greeting cards. In 1928, the company introduced the brand name Hallmark Cards, after the hallmark symbol used by goldsmiths in London, and in 1944 the adage "When you care enough to send the very best" was first heard by the public.

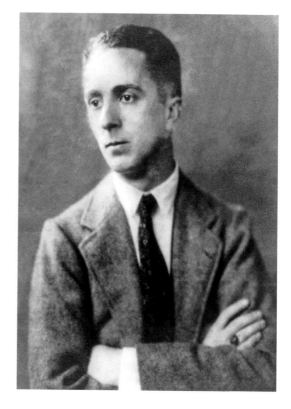

Hallmark Cards produced a series of Christmas cards in the 1950s and 1960s that depicted American life during the holidays. Here Norman Rockwell's card "Santa at the Map" portrays Santa Claus seated on the stop of a ladder holding his book *Extra Good Boys & Girls* as he traces his route to be taken on Christmas Eve on a wall map of the Western Hemisphere. Notice that Santa Claus has a halo (St. Nicholas) and over his ear is a quill pen.

Norman Perceval Rockwell (1894-1978) was a well-known author, painter and illustrator and his artistic works enjoy a broad popular appeal in the United States for its reflection of American culture. Rockwell is most famous for the cover illustrations of everyday life he created for *The Saturday Evening Post* magazine over nearly five decades. He was also associated with Hallmark Cards in the post-World War II era when he created some of the most charming Christmas Cards of the period.

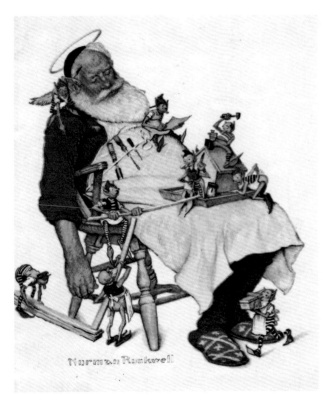

Santa Claus, or St. Nicholas as he sports a golden halo, is depicted by Norman Rockwell in "Santa Up a Ladder," snoozing in his armchair as busy elves continue the design and production of the multitudes of toys necessary for delivery on Christmas Eve.

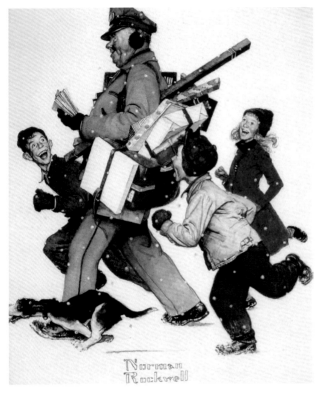

"Jolly Postman," depicted as laden with mail and packages, was the center of attraction by smiling neighborhood children and their dog as they walk with him to neighborhood houses, hoping to receive one of the envelopes or packages addressed to them. Norman Rockwell truly captured the excitement and anticipation of the holiday season with the daily arrival of the postman.

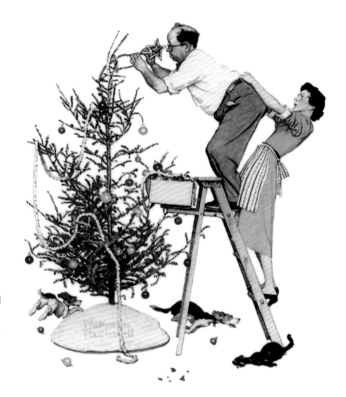

"Trimming the Tree," can be something that takes time and effort to make it appear just-so, however when mother needs to step on the bottom step of the ladder to hold onto father's belted trousers as he perches on the top step to affix a star at the top of the tree, it can be tricky business—especially with the family's dogs chasing the cat in circles around the tree.

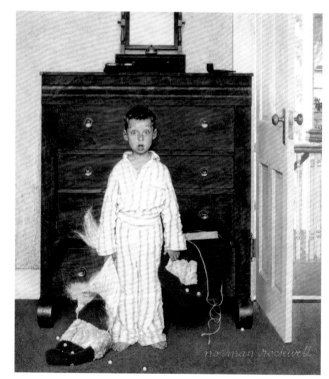

"The Discovery" was painted by Norman Rockwell in 1956, depicting a young boy rummaging in the bottom drawer of a bureau and discovering Santa Claus' outfit. The look of utter astonishment at this revelation was incredible, making Norman Rockwell one of the most popular artists in the mid-twentieth century.

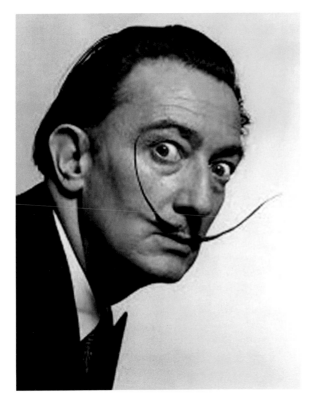

Salvador Dalí (1904-1989) (Salvador Domingo Felipe Jacinto Dalí i Domènech, Marquis of Dalí de Púbol) was a prominent Spanish surrealist artist whose Christmas cards were among the more *avant-garde* of the post-World War II period. With a flamboyant waxed mustache he was among the best-known surrealist painters and his Christmas Cards, though they often included traditional aspects of Christmas such as Santa Claus or the Three Wise Men, would be reinterpreted as *outré* and unique examples of his art.

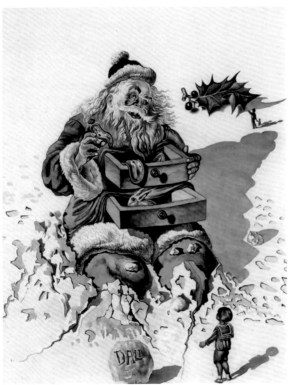

This Christmas card by Salvatore Dali that the author received was to almost instantaneously become an iconic card, showing Santa Claus sitting in a snowdrift with drawers projecting from his chest and stomach that included his signature melting clock and a rabbit within the drawers. Dali was an artist who did not conform to traditional depictions of Christmas, but created *outré* and interesting juxtapositions.

SIX

BOSTON'S DEPARTMENT STORES

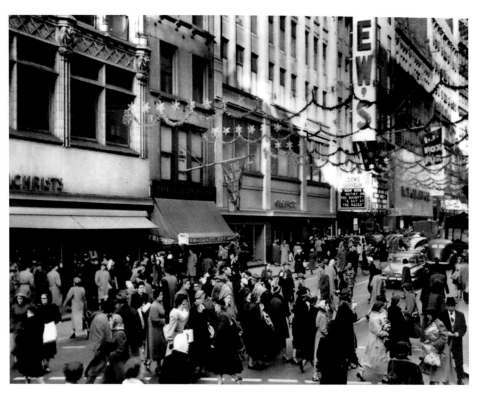

Washington Street in Downtown Boston was lined with not just department stores, but many small specialty shops. The street had Christmas lights strung from one building to another with electric stars and roping suspended from wires. In the twentieth century, before the advent of the suburban shopping malls, going to town was not just exciting but where there were wider selections. From the left were Gilchrist's, E. B. Horn Company, Gilchrist's second entrance, I. J. Fox Furrier, Loew's, and W. T. Grant, with throngs of shoppers.

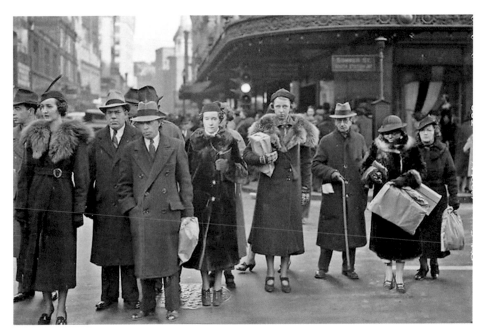

A group of very well-dressed shoppers cross Summer Street at Washington Street in the 1920s in front of William Filene's Sons Company. With boxes and bags of shopping, it seemed that everyone was able to find that perfect gift for family and friends in the many department stores in Boston.

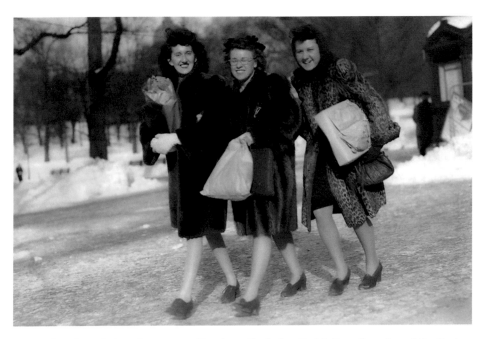

A trio of package-laden shoppers walks along the Lafayette Mall on the edge of the Boston Common that parallels Tremont Street in the 1940s. Wearing warm fur coats, they were typical of the shoppers who went to town for a day of shopping. In the distance can be seen the dome of the Massachusetts State House that had been painted gray during World War II to avoid being a possible target for bombing.

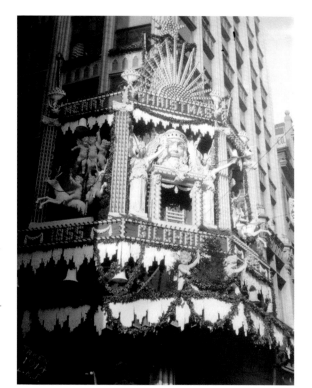

Gilchrist's Department Store was at the corner of Washington and Winter Streets in Boston. This festive corner Christmas display in 1914 had Santa Claus in the center above the fireplace he would descend on Christmas Eve flanked by angels with trumpets and three-dimensional reindeers, putti and bells, all of which were brilliantly illuminated in the evening to the delight of shoppers and those in town to marvel at the displays.

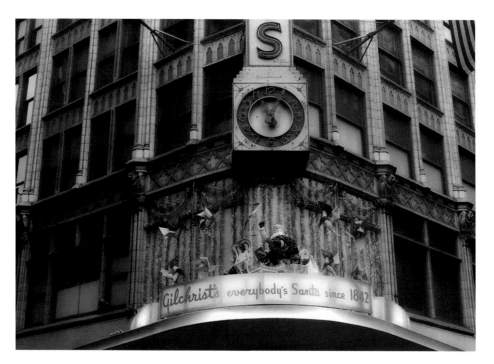

The corner display at Gilchrist's Department Store in 1942 had a much more somber display than in previous years as it was the height of World War II. Santa Claus, seen in the center above the parapet was seen in his sleigh with reindeers and the sign said "Gilchrist's … everybody's Santa since 1842."

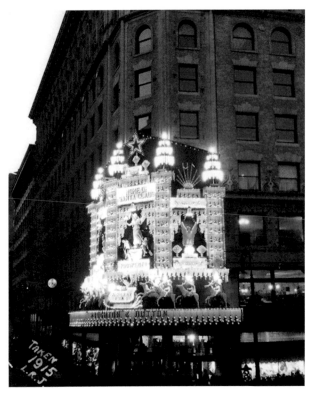

Houghton & Dutton was a ten-story department store designed by Burr & Sise and located in the Albion Building at the corner of Tremont and Beacon Streets where it was prominently located for over 50 years. Founded by S. S. Houghton and Benjamin Franklin Dutton, the store had a great following and the company was later successfully led by Harry Dutton, a nephew of Benjamin Franklin Dutton, who served as president. Their magical Christmas displays on the corner of the store were legendary and this electrical extravaganza was the 1915 display, stating in large letters that this was the "Home of Santa Claus." Along the parapet he was seen in his sleigh with his reindeer all in electric lights

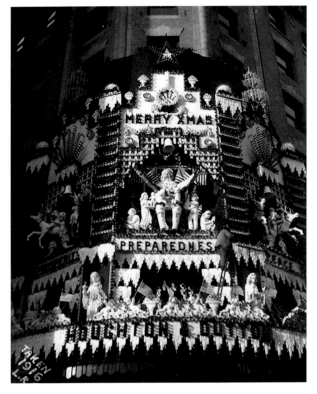

During the holiday season in 1915, Houghton & Dutton had an even more stupendous display above the store entrance with not just electric lights of all shapes, sizes and colors but three-dimensional figures and American flags with the word "Preparedness" in the front, flanked by "Prosperity" and "Peace," prominently featured as the neutral United States was preparing for entry into World War I, which would occur on April 6, 1917. The United States joined their Allies in Europe after the atrocities in Belgium in 1914 and following the sinking of the passenger liner RMS *Lusitania* in 1915, as the American people increasingly came to see Germany as the aggressor in Europe.

R. H. White's was founded in 1853 by Ralph H. White and their store was designed by Peabody and Stearns in 1876 at 518 to 536 Washington Street. Filene's bought the store in 1928 and then in 1944 City Stores took over. A Patriot's Day Parade was held in honor of their 100th year and many store window displays were featured throughout the year as a way of marking this very special occasion. During the Christmas season a huge Santa Claus, holding a Christmas tree with electric lighted stars in one hand and a bag of toys in the other, was erected at the corner of the store to the delight of children and shoppers.

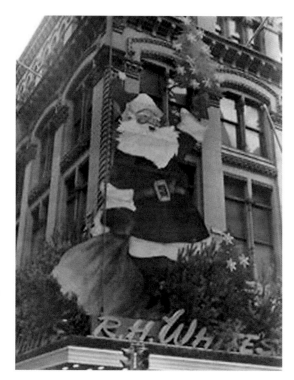

The Brewer Fountain on Boston Common was decorated with electric lights strung around the basin, and in the distance from a star string of electric lights created a tree on the façade of R. H. Stearns Company at the corner of Tremont and West Streets. Richard Hall Stearns (1824-1909) opened a store that became a fixture in the downtown Boston shopping scene for over a century, and also opened a few branch stores in the greater Boston area. The store catered to the "carriage trade," a term used for well-to-do customers, and was particularly noted for its women's clothing, the "stereotypical Stearns customer being a white-gloved older woman of subdued upper-crust demeanor, although well-crafted children's items were also sold, as well as men's clothing, silver and crystal – but not appliances."

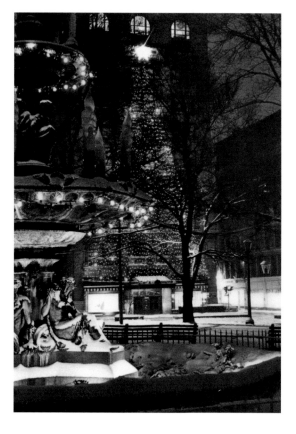

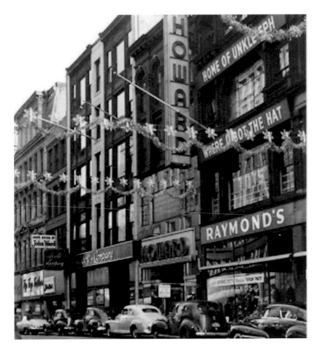

Raymond's, seen here on Washington Street, was a traditional department store that was beloved by Bostonians as the "Home of Unkle Eph—Where U Bot the Hat." The store was prominently sited and the sales were phenomenal, and many Boston families purchased their oriental rugs at Raymond's, for which it was well known. Washington Street had festive decorations that were strung from one building to another, and created a colorful canopy that shoppers walked under when illuminated in the evening.

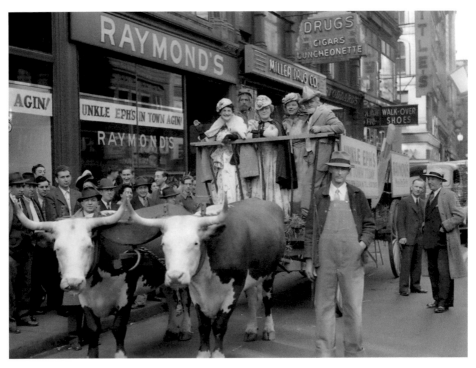

The trademark "face" of Raymond's was Unkle Eph and Aunt Abby, who often arrived in Boston in a rough wood tumbrel drawn by a pair of Texas Longhorns. The couple was joined by friends as the conveyance pulled up in front of the store that proclaimed in its display window that "Unkle Eph's in Town Again" and which brought thousands to watch the procession from the train station to the store, and hopefully into the store to make purchases.

Filene's was founded by William Filene (1830-1901) who opened one of the largest specialty stores in the country, known as the William Filene's Sons Company, the "World's Largest Specialty Store." The impressive store was designed by Chicago architect Daniel Burnham and built in 1912 at the corner of Washington and Summer Streets. It had a parapet on both sides. During the holiday season, beautifully decorated Christmas trees lined the parapet.

Edward A. Filene (1860-1937) and his brother Abraham Lincoln Filene (1865-1957), considered innovators in merchandising techniques and employer-employee relations, assumed management of the store in 1891 and inherited the store upon their father's death in 1901. They would establish employee welfare plans, paid winter vacations for employees, employee purchasing discounts, profit sharing, health clinics, insurance programs, and credit unions. They also introduced Filene's Basement where the "Automatic Markdown system" was compelling enough to lure shoppers of all different classes to the Basement, where everyone was treated equally in their efforts to shop for deals.

On a morning after a snowstorm, not only Summer Street but all of the trees on the parapet above the entrance to Filene's were covered with snow. The subway entrance was on the far right which allowed those traveling to town ease of access to the stores. On the left can be seen Gilchrist's.

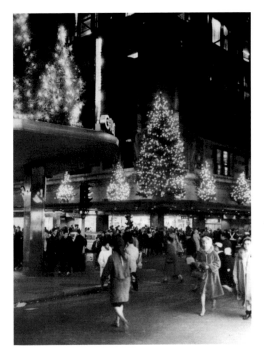

A festive scene greeted shoppers at the junction on Washington, Winter and Summer Streets with Christmas trees bedecked with electric lights, which were on the parapets above the entrances to Gilchrist's on the left and Filene's across the street. On Monday evenings the stores were open late, so it was a festive atmosphere with electric lights and decorations and throngs of shoppers.

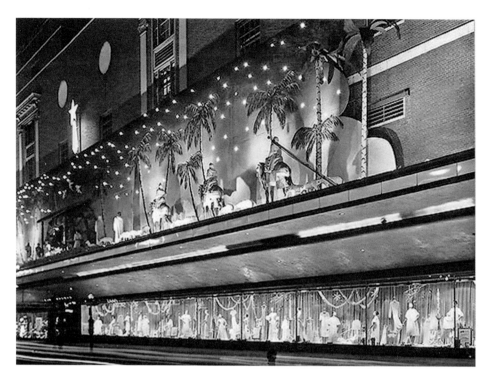

Jordan Marsh had a major addition designed by Perry, Shaw, Kehoe and Dean, built in 1949 for the centennial of the store at the corner of Summer and Chauncy Streets. On the parapet along Summer Street a Nativity *crèche* was placed with the figures of Joseph, Mary and the baby Jesus, shepherds with their sheep, the three Wise Men riding camels and three-dimensional palm trees. With twinkling electric stars and recorded holiday music, shoppers were put in the holiday mood. Illuminated at night, with the Star of Bethlehem and twinkling electric stars, it was seen from all directions.

Eben Dyer Jordan (1822-1895) was the co-founder with Benjamin Lloyd Marsh (1823-1865) of Jordan & Marsh in 1851. It was said of the partners that they "excelled through character, knowledge of the business, courage and genius for hard work." Jordan and Marsh were skillful and enterprising entrepreneurs and they would rapidly expand their business from wholesale to retail.

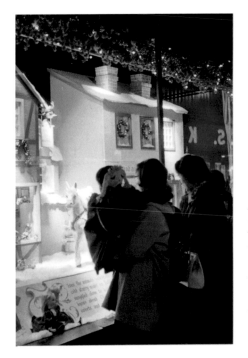

A miniature illuminated Victorian Village was created in the huge display windows along the Washington Street facade of Jordan Marsh, which brought thousands of people to see the display day and night. After the Santason Parade on Thanksgiving Day morning, which had been started in 1929, ended in 1943, Jordan Marsh created these wonderful windows of holiday cheer that proved immensely popular and brought thousands of shoppers who "window shopped."

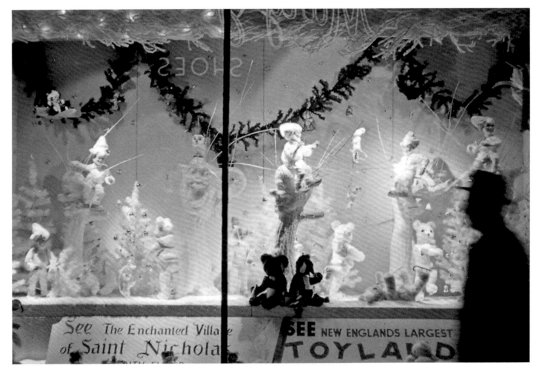

The window displays along Washington Street not only advertised the Enchanted Village of Saint Nicholas at Jordan Marsh, but also "New England's Largest Toyland" that was on the fifth floor of the Jordan Marsh Annex. These brightly illuminated display windows not only displayed window dressers' creations, but were an important part of advertising to those who window shopped.

Santa Claus sends a colorful card to the children of Boston from his home in the North Pole that depicted a house that he "built for the dollies" and called My Dolly's Home. Santa Claus said that this house was "taller than your Daddy. There were so many dollies it looked like a big Hotel, so I gave it a name. I called it 'My Dolly's Home.'"

trains do whizz and whirr around the tracks. And I have a life-size Shetland pony (only of course he is'nt alive), the fattest little fellow you ever saw. I don't know how I'm going to get him in my sleigh. I guess I'll have to bring him to life and let him fly along beside my sleigh just for Christmas Eve.

But, my, oh, my, Kiddies, I'm telling you too much. I want to save some things for surprises, so goodbye, kiddies, until I see you in Toyland.
Lovingly
Santa Claus

P.S.: Oh, me, Oh, my! I almost forgot to tell you about the big house I built for the dollies. It is taller than your Daddy. There were so many dollies it looked like a big Hotel, so I gave it a name. I called it "my Dolly's Home." You just must see it. ——
Santa

At Toyland
JORDAN MARSH COMPANY

Santa Claus was at Toyland at Jordan Marsh, where there were things to delight every child in Boston. Of course there were train sets that "whizz and whirr around the tracks" as well as a life-size Shetland pony that must have created excitement. He said "But, my, oh, my, Kiddies, I'm telling you too much. I want to save some things for surprises, so goodbye, Kiddies, until I see you in Toyland."

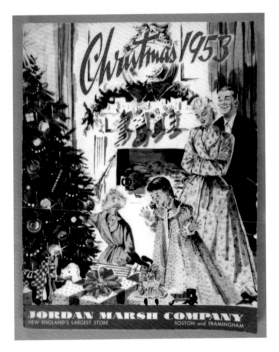

The Christmas 1953 Jordan Marsh catalog was eagerly awaited by the public as it was a veritable "wish book" of clothing, furniture, toys, appliances and gifts that was lavishly illustrated. Jordan Marsh Company offered "Christmas Gifts for All the Family from New England's Largest Store" in Boston and Framingham and gifts could be bought in the store or ordered and shipped to one's home.

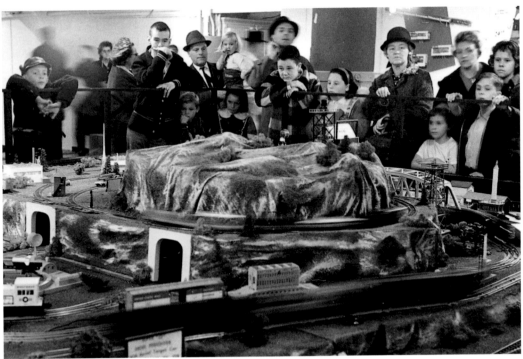

A large model train set with curving tracks that encircles Styrofoam hills and goes through tunnels and over trestle bridges attracted the undivided attention of children and teenagers, as well as adults during the Christmas season. These model train sets would be set up with complete villages and other realistic scenes to hopefully attract customers to purchase them, but all the while entertaining a wide array of people in Toyland.

F. A. O. Schwarz was the premier toy store that was located in the 1960s on Newbury Street in Boston. Seen from inside the store through the plate glass display window is a family with their young child admiring the wide selection of toys. Founded in 1862 under the name "Toy Bazaar" by German immigrant Frederick August Otto Schwarz, it was a toy store of distinction in Boston and his kinsman Robert Schwarz had a "Toy Emporium" at 499 Washington Street in the late nineteenth century.

A visit to town would always, one hoped, include a visit to Bailey's on West Street. Known for their delicious ice cream and candy selection, women who worked at Bailey's created sundaes that were generous in their serving of ice cream, along with hot fudge or butterscotch sauce and marshmallow that overflowed the sides. These sundae dishes had attached under plates that caught the delicious overflow, and were a beloved tradition in Boston.

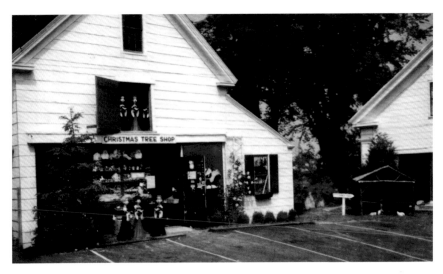

The original Christmas Tree Shop was located in a former barn on Willow Street near Route 6A in Yarmouth Port on Cape Cod. Started in the 1950s, the shop sold Christmas gifts and ornaments and had cassocked choral statues in front as well as in the hayloft. Charles and Doreen Portnoy Bilezikian would buy the shop in 1970 and transform it into "a destination for one-of-a-kind items at real bargain prices." The Christmas Tree Shops were expanded over the years and after 2003 when it was bought by Bed Bath & Beyond would be expanded to 70 nationwide stores. As the store jingle says "Don't you just love a bargain?"

C. Kelton Upham (1899-1979) was a retired English teacher in the Everett Public Schools who in retirement would portray Santa Claus at Filene's in Boston throughout the 1950s and early 1960s. A descendant of Amos Upham, for whom Upham's Corner in Dorchester, Massachusetts, was named, he was a jovial figure who often sat on a red velvet throne in a display window facing Summer Street, waving and smiling to the many children who probably gazed at him in awe.

Paul Devaney and Mary Devaney visit Santa Claus in 1959 at Jordan Marsh Department Store, and he sits on a velvet upholstered armchair with a large cartouche at the top with an "S" for Santa Claus. At Jordan Marsh, Santa Claus was at the end of the Enchanted Village, and children would be welcomed with a candy cane as they waited patiently tvo sit on Santa's lap. (Courtesy of Mary E. Paul)

Ruth Ann Dolley sits on Santa Claus' lap in 1950 at Jordan Marsh, with a muff to match her new hat and coat. She said she "felt like a princess. Waiting in line to see Santa Claus always seemed so long and then … it was my turn! What I remember best about this photo is asking Santa Claus for a Tiny Tears doll. She cried 'real tears' after you fed her a bottle of water and even blew bubbles. I was excited to tell Santa where he could find her and exactly which window she was displayed in, 'next to the teddy bears.'" (Courtesy of Dolley Carlson)

Rosemary and Kathy Donovan sit on either side of Santa Claus at the R. H. White Department Store on Washington Street in Boston. Rosemary Donovan Finn said, "We frequently went on the trolley to view the Christmas lights and to visit Santa at Jordan's and R. H. Whites. We were thrilled to go on the trip as we got dressed up in our best dresses tucked into our itchy snow suits' leggings. In the forties, no matter what the age, you always dressed for town ... we wore our best hats and gloves and still had to be warm for those cold snowy winters of the mid-forties. We would visit the crèche on the common and see all the lights." (Courtesy of Rosemary Finn and Kathryn Malt)

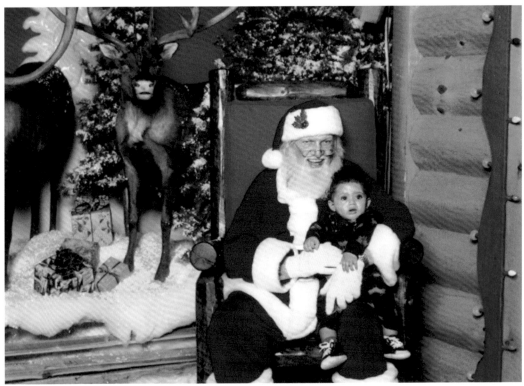

Sebastien Minuty sits on Santa Claus' lap in 2016 in a decidedly Adirondack-themed chair at the Bass Pro Shop at Santa's Wonderland in Patriot Place, replete with faux-log cabin walls and antlered deer in the background that add that festive touch along with cotton batting imitating snow and decorated Christmas trees. (Courtesy of Angela Goodwin Minuty)

THE ENCHANTED VILLAGE
OF SAINT NICHOLAS

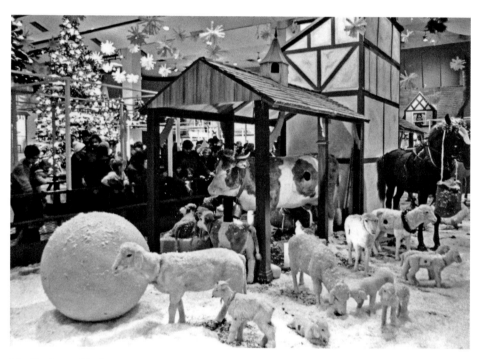

The Enchanted Village of Saint Nicholas at Jordan Marsh Department Store was a "mixture of Tudor Revival and storybook style, with half-timbering and mullioned windows that mimicked medieval cottages and English country houses." Seen from the walkway, the facades of the village houses and shops had automated figures that peeked from doors and windows as well as a cat that sat on the chimney top.

Edward Mitton said "this delightful, authentic panorama, with its wonderful animated characters at work and play, is for the enjoyment of all children and adults. We hope it will cast a spell of enchantment over all our New England friends … adding to a brighter, gayer, more delightful Christmas season."

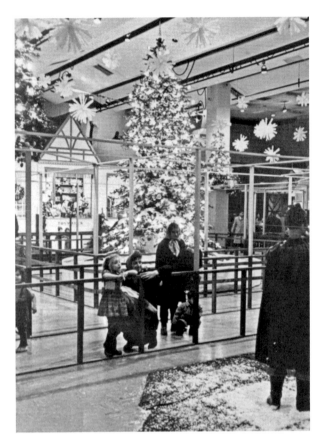

Children peer through the wood stanchions along the walkway to see the exhibits, and their parents were equally charmed by the automated elves in the foreground and attention to detail. As it really was intended to be a village, even automated cows, horses, dogs and sheep were part of The Enchanted Village of Saint Nicholas. Here, under a small wood-shingled shed, the animals would move in unison, creating a bucolic barn scene as people passed through the village.

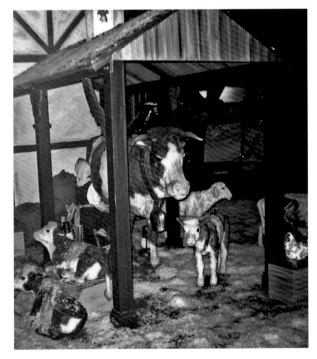

The Enchanted Village of Saint Nicholas was said to be a "mixture of Tudor Revival and storybook style, with half-timbering and mullioned windows that mimicked medieval cottages and English country houses." Here animated figures of cows, bulls and sheep peer from a wood shed as they move in unison to create a fascinating glimpse into a depiction of nineteenth century village life.

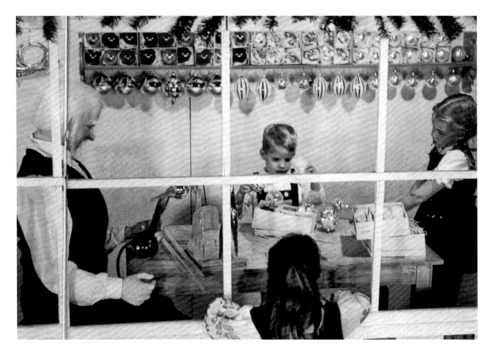

A Hofmann-built glassblower in the Ornament Shop in the Enchanted Village of Saint Nicholas was photographed by *Look* magazine in December 1959 with three children admiring the multi-colored ornaments, which are of blown glass and decorated with traditional Bavarian designs.

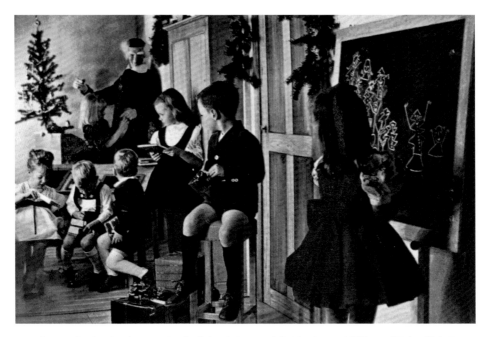

A Hofmann-built schoolmaster in the School House of the Enchanted Village of Saint Nicholas at Jordan Marsh Department Store is surrounded by children in the *Look* magazine photograph of December 1959. In essence, the children created an impromptu Christmas party in the school, as the automated schoolmaster oversees the festivities.

In the Enchanted Village that now is held at Jordan's Furniture in Avon, Massachusetts, during the holiday season, thousands of people visit and often bring their children and grandchildren to see what they had enjoyed 50 or 60 years ago. Here two animated figures of boys are seen standing in front of the General Store, which is not only stocked with everything one could possibly need in the nineteenth century, but is festively decorated with wreaths and swags and tartan bows and ribbons.

This parlor scene at Jordan's Furniture shows two animated figures of children in muslin nightdresses standing before a fireplace in a nineteenth century parlor, with the toys left by Santa Claus on Christmas Eve. The figures would move in unison, and with twinkling electric lights on the Christmas tree and a swag along the mantle, their joy on Christmas morning at a bow-bedecked tricycle and toys under the tree was incredible.

EIGHT

BOSTON'S CHRISTMAS TREES

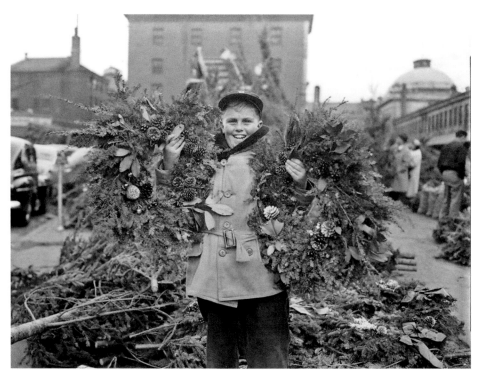

A young boy holds decorated evergreen wreaths that were offered for sale at North Street adjacent to Faneuil Hall and Quincy Market. In the mid-twentieth century, this was the meat and produce exchange for the city of Boston, and there were many purveyors of goods located there.

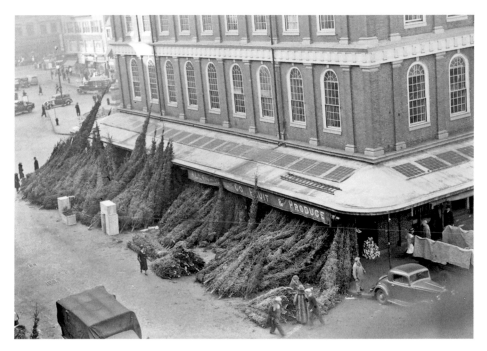

Christmas trees of every size and height could be obtained at Faneuil Hall with the trees stacked or leaning against the parapet covering the first floor market. Peter Faneuil (1700-1743) had donated the hall to the town of Boston in 1742 with the provision that the first floor always remains a market. The second floor has long been a meeting hall that was called the "Cradle of Liberty" during the American Revolution and the attic is the headquarters of the Ancient and Honorable Artillery Company.

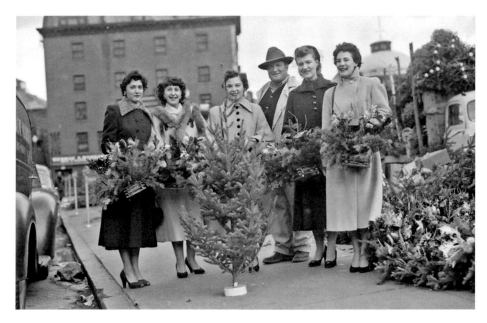

The wide selection of Christmas decorations available at Faneuil Hall and Quincy Market included tabletop trees, wreaths and evergreen baskets that were often used to decorate graves. The man in the center was selling these decorations as a group of women pause for the photographer in 1952.

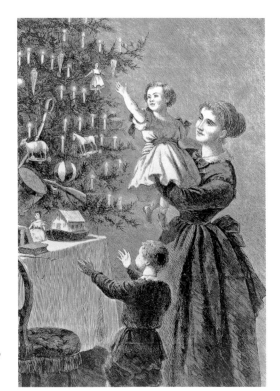

A mother holds her daughter, who reaches for an ornament on this Victorian Christmas tree. Still a tabletop tree in the 1870s, it was decorated with small dolls, a sheep pull toy, and a ball and drum, and on the tabletop is a doll and a small toy house. The young boy also reaches towards the table as the wax tapers illuminate their faces.

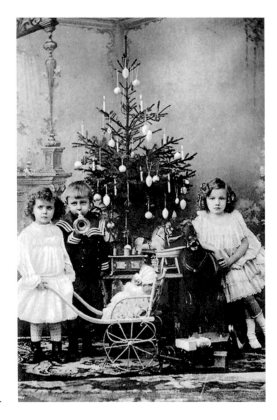

These three children pose in front of their Christmas tree in the late nineteenth century. The girls are dressed in white muslin dresses and their brother is in a sailor's suit as he blows a brass horn. The tree is decorated with lighted wax tapers and ornaments suspended by ribbons. Their toys include a doll in a two-handled perambulator, a rocking horse and a stuffed horse that the girl on the right leans on.

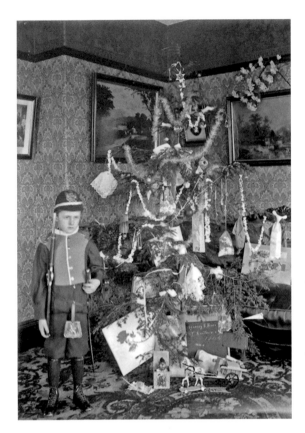

A young boy is dressed in a quasi-military uniform replete with a hat sporting a badge and a rifle under his arm as he stands before the Christmas tree in 1900. The tree is decorated with strings of popcorn, silver tinsel ropes, cards, bags of candy and lace handkerchiefs. His toys are arranged in front of the tree and include a toy horse-drawn wagon.

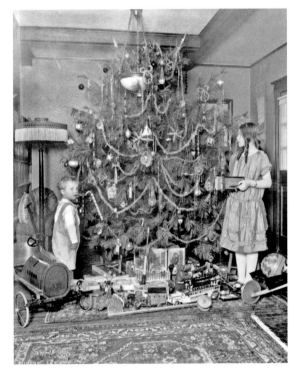

By 1915, Christmas trees were often the height of the ceiling and more full than those of the previous decades. Here, two children pose on either side of a tree which is decorated with toys, glass ornaments, candy canes and strings of silver tinsel rope garland. The toys under the tree include a metal toy car on the left, books, games, toy cars, fire engines and a wheelbarrow with a toy ball on the right.

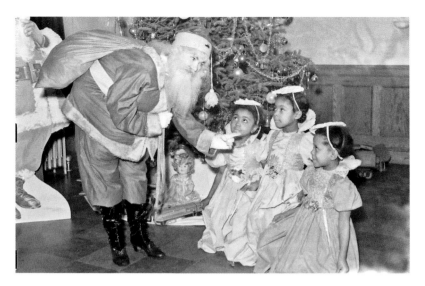

In 1934 Santa Claus, with a bag of toys and goodies, leans towards three little girls obviously asking, "Have you been good little girls this year?" Many children agonized in the weeks leading up to Christmas as to whether one's stocking would be filled with small toys, candy and fruit or the dreaded coal that was given to those who were naughty. With their lace caplets, these three girls look angelic and undoubtedly received dolls like the one seen under the tree. Notice the life-sized cardboard cutout of Santa on the left.

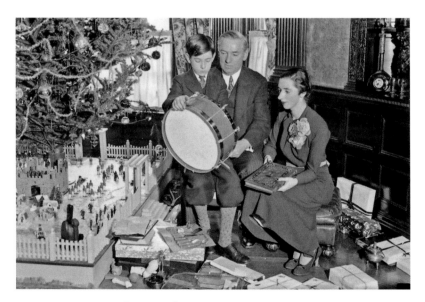

James Michael Curley (1874-1958), seen with his wife Mary Emelda Herlihy Curley and his son Francis X. Curley holding a drum, sit in their dining room at their home on the Jamaicaway in Jamaica Plain, Massachusetts, as they open their Christmas presents. The large decorated Christmas tree with large ornaments and silver tinsel rope garland can be seen on the left, and it is encased by a picket fenced platform upon which is a crenellated castle in the center and toy soldiers and horses. The gifts were strewn in the foreground, almost all wrapped in white gift paper with ribbons.

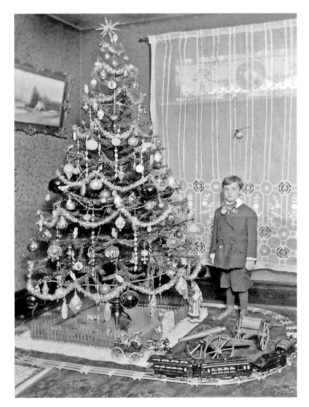

A well-dressed young boy in a tweed knickerbocker suit and a florid bow tie stands beside his ceiling height, beautifully decorated Christmas tree that has electric lights, glass ornaments, and silver tinsel rope garland, and is set within a square picket fence. His presents included a train set with the tracks encircling the tree, as well as a horse-drawn coach and toy cannon with a two-wheeled ammunition caisson.

This little girl must have been very good as Santa Claus left a large number of presents on Christmas Eve. She pushes a baby perambulator, but behind her is a large doll house. On the left is "Dolly's Wardrobe," and stuffed animals. The tree, by 1960, had not just electric multi-colored lights but now the silver tinsel icicles that was to create and almost winter-like reflective effect to the tree with the lights.

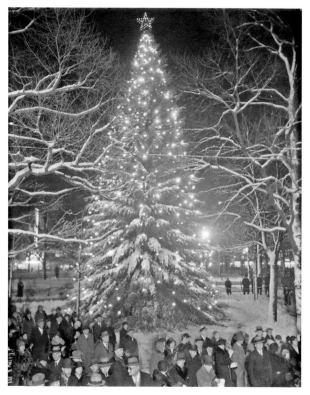

A smiling baby is seen holding an ornament along with his pet dog flanking the Christmas tree that was set up in front of the mantle in the living room. The tree is decorated with large glass ornaments, silver tinsel icicles and silver tinsel rope garland. A stuffed donkey is set on top of wrapped Christmas presents. As it covers the fireplace, how did Santa Claus get down the chimney to leave the presents?

The idea of a Boston Community Christmas Tree was started by John F. Fitzgerald (1863-1950) when he was mayor of Boston. He admired a Christmas tree in front of the Greenwood Memorial Church in Four Corners, Dorchester, and by 1907 had introduced a community tree that was on Boston Common. Seen here, it was an enormous tree decorated with multi-colored electric lights and surmounted by a five-pointed electric star. Hundreds of Bostonians would come to its lighting and it was a popular attraction that led to the trees on Boston Common being draped with strings of electric lights during the holiday season.

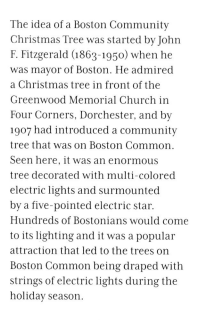

In 1965 it was said that 30,000 Christmas lights were strung on trees at the Prudential Center in Boston's Back Bay. These two men decked out trees, shrubs and fountains with assorted color lights. It was said that the "lights combined will draw enough electrical power to light about 750 average size homes, per hour. During the whole Christmas season the lights will draw 28-million watts of electricity, enough for some 30,000 average size homes."

By the 1960s it was decidedly hip to have a Christmas tree of silver aluminum that often had a four-color revolving light. As it turned, it reflected the tree in red, green, blue and white colors. Here the Boston Insurance Company office had one of these new aluminum trees with office workers collecting gift-wrapped presents for the United States Marine Corps Reserve annual drive for needy children, "Toys for Tots." From left to right are Judy Shood, Marine Sergeant Richard Sutherd and Carmi Vitale.

NINE

THE BOSTON POPS, BLACK NATIVITY, ICE CAPADES

Young dancers in the Nutcracker have long been a tradition at the Boston Ballet. The Nutcracker has been a perennially popular production during the Christmas season in Boston and brings joy to thousands of people with the wonderful costumes, ballerinas and of course the Nutcrackers!

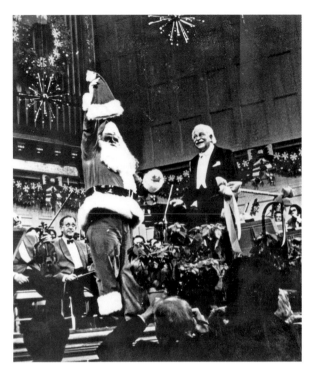

Arthur Fiedler greets Santa Claus who has arrived on stage at Boston Symphony Hall during the 1977 Christmas at Pops. The Boston Pops Orchestra and the Tanglewood Festival Chorus present an hour of popular holiday music which features a rousing sing-along of "We Wish You a Merry Christmas." By the 1970s Christmas at Pops was televised and had a loyal following of aficionados.

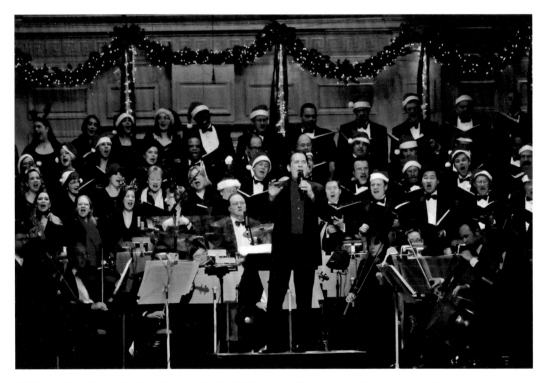

Keith Lockhart leads the Tanglewood Festival Chorus at Christmas at Pops in 2005. The music was traditional and the attire formal, but with festive Santa caps, reindeer horns and colorful scarves, the singers lead the audience, who share in the joyous aspect of holiday music.

In the 1996 production of the Boston Ballet's The Nutcracker, Meghan Maloney, in the center, has her lace cap secured by Rebecca Melssner on the right and Arianna Dedes on the left. With colorful costumes, sewn with brilliant sequins, the dancers bedazzled not just their parents but the entire audience.

Elma Lewis (1921-2004) was a noted arts educator and the founder of the Elma Lewis School of Fine Arts, and she brought Black Nativity, originally known as "Wasn't It a Mighty Day?," to the stage in Boston. Written by Langston Hughes (1902-1967), Black Nativity is the retelling of the classic Nativity story with an entirely black cast with traditional gospel spirituals. Black Nativity has been an annual production in Boston, originally under the Elma Lewis School for the Fine Arts and more recently being performed at the Paramount Theatre in Boston.

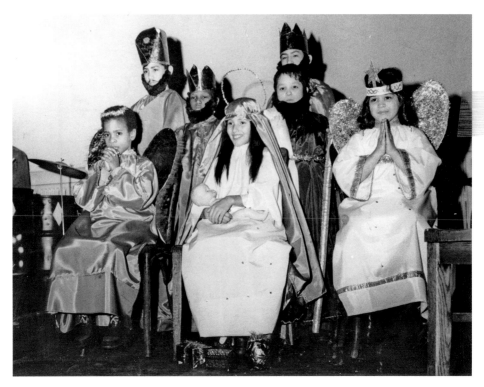

In 1971, an Epiphany Celebration was held for children at the "Little City Hall" in Boston's South End. Often called Pequena Navidad or Little Christmas, this celebration was held among the Spanish-speaking community and had costumed children portraying the birth of Jesus Christ. Maria Flores, in the center, portrays the Virgin Mary and cradles a baby Jesus flanked by two angels with Joseph and the Three Wise Men behind her.

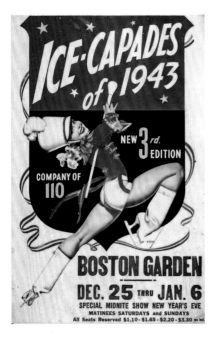

The Ice Capades was a popular event that was held annually at the Boston Garden on Causeway Street in Boston. Seen here in an advertisement from 1943, there were 110 performers in the new third edition of the Ice Capades. With fanciful costumes, rousing music and dance, all performed in ice skates, the Capades were not just well attended at evening and matinee performances, but even a special midnight show that was performed on New Year's Eve.